OLD MAN GOYA

OLD MAN GOYA

Julia Blackburn

PANTHEON BOOKS

NEW YORK

All rights reserved under International and Pan-American
Copyright Conventions. Published in the United States by Pantheon
Books, a division of Random House, Inc., New York, and in Canada
by Random House of Canada Limited, Toronto. Simultaneously
published in Great Britain by Jonathan Cape, an imprint
of Random House U.K., London.

Pantheon Books and colophon are registered trademarks
of Random House, Inc.

A Cataloging-in-Publication record has been established
for *Old Man Goya* by the Library of Congress.

ISBN: 0-375-40611-5

www.pantheonbooks.com

Printed in the United States of America
First American Edition
2 4 6 8 9 7 5 3 1

In memory of my mother
Rosalie de Meric (1916–1999)

He knows neither what he wishes for, nor what he can hope for. He is celebrated for his restlessness, his angers, his passions; he is full of curiosity; he frequents fairs and popular fêtes, taking a lively interest in circus animals, acrobats and monsters. He paints, draws, engraves, learns lithography and initiates himself in all the technical discoveries. His lucidity is absolute.

(Goya at the age of seventy-nine)

OLD MAN GOYA

1

I have been busy with Goya for many years. When I was a child there was a paperback edition of his etchings, tucked small and unobtrusive in the bookcase in my mother's painting studio. The white spine of the book had been broken and partially torn away, exposing the intimacy of the stitches that bound the pages together.

On the cover a young woman sat on a low stool and challenged me or any other stranger with an unblinking gaze. Her long hair was being brushed by a smiling woman who was almost concealed in the shadows, while a third woman, terrifying and ancient and dressed in white robes, was crouched on the floor like a heap of pale stones, turning the beads on her rosary and the dangerous thoughts in her head.

The artist's signature, Fran de Goya, appeared underneath the picture, printed in a bright red that looked to me like fresh blood, the final 'a' twirling its tail downwards with the wild energy of a spinning top.

I used to steal this book from its shelf and take it quietly to my room. I would stare at the cover and try to understand what secret things had just happened and were about to happen here. I would open the pages at random so that

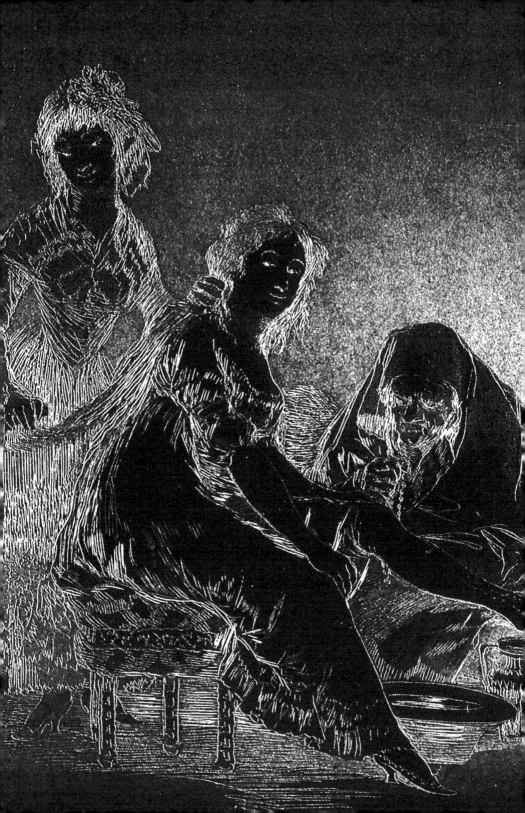

the other dark and interrupted stories could play before my eyes. People becoming animals and animals becoming people. Masks to hide a face and faces turning into masks. Leathery old skin next to soft young skin and a thick blackness on all sides out of which monsters could emerge like rabbits pouring in an endless stream from a magician's hat. I was terrified by what I saw and yet I felt brave and somehow invincible because I had dared to look at it.

I have the same book lying on the table beside me now. It is more battered than before. The broken spine is held together by strips of Sellotape that have become dry and brittle. A blot of ink has fallen in a little explosion on the delicate fabric of the seated woman's dress. A corner of the cover is missing. But when I turn the pages the shivering intensity of those images is as sharp as ever and as vivid as memory itself.

So that is the first root of my connection with Goya. He seemed to belong to me like a member of my own family, distant, but sharing the same blood. For a long time he sat quietly in the back of my mind, stirring occasionally, but not making any demands until the day when I went to the Prado Museum in Madrid and entered the two big rooms that hold his so-called Black Paintings. It was the noise of them that struck me first: an echoing reverberation of savage human voices all competing with each other and demanding to be heard. It was only later that I began to notice the silences as well, the great pools of silence that were every bit as powerful as the noise.

The person standing next to me explained that Goya was deaf when he made these pictures; he was stone deaf from the age of forty-seven until he died at the age of eighty-two. And that was when I decided I wanted to find

out more. I wanted to know what sort of world this deaf man had inhabited and how he had managed to live with the isolation of deafness and how it had changed the way he used his remaining senses.

Finding out about him has been an odd task. I can speak a sort of fluent pidgin Spanish, which means I can talk to people at length if they are patient with me, but even with the help of a big dictionary I can only struggle through a few pages of written Spanish, and so for the most part I have had to depend on what has been published in English or in French. But whenever I lost courage I would remind myself that even someone much more qualified than me could only try to piece together the narrative of Goya's life from the fragments of information that have survived him. The inventory from the sale of a house might prove when a particular painting was done; a drawing of a naked woman might suggest a love affair; a passing comment in a letter might indicate a political opinion. Or not. Goya leaves everyone free to make their own interpretation of the kind of person he was; what he believed in or did not believe in; who he loved and did not love; and whether he was tormented by savage nightmares that brought him close to madness or was simply a witness to a time in history when nightmares of one sort or another were being enacted on the streets and in the open countryside every day of the week.

In order to try to see what Goya saw, I have visited the places he knew well: the village of his childhood, the farmhouse where he stayed with the Duchess of Alba, the cities of Zaragoza, Madrid, Cadiz and, finally, Bordeaux. In my mind's eye I can now look across the landscapes that he once travelled through, I can walk the same streets, I can

gaze out of the window of the house in which he was born and the house in which he died. Maybe that is another way of meeting a man who is dead.

In the telling of this story I have concentrated on what happened to Goya after the illness which made his world turn silent and forced him to depend upon his eyes for everything. Instead of illustrations of his drawings or paintings I have included some photographs of his etching plates. I wanted to use them because here you can see what he saw while he was working; you can see the huge energy of the man as he scratched and scraped and burnt the images he was creating on the surface of the metal.

2

Not long after I had started finding out about Goya, my mother became very ill and nothing could be done to hold back the process of her dying.

She stayed with me for a while in a room in which I had hung some of her smaller paintings on the walls and had put photographs from the story of her life along a shelf facing the bed.

She lay there very quietly. She was not in any pain, nor did she appear to be afraid of the many changes that were taking place as step by step her body ceased to work for her. She observed it all with a curious detachment. She made jokes and did her best to comfort the people she had been close to.

Over the years she and I had always swung between rage and love, between tenderness and resentment, but now for the first time we were able to talk about the complexity of the past without the confusion of blame. We talked a great deal during the days and the long nights.

She had already given me the paperback of the Goya etchings that I knew from my childhood, and some old postcards she had bought from the Prado Museum were tucked among its pages. I now placed the still life of a heap of dead but

golden fishes on the shelf in the company of my mother as
a smiling girl with dimples in both her cheeks. And then she
and my father were standing side by side in a mountain land-
scape and you could see that they still loved one another.
Then she was holding me as a baby on her lap and she was
with my two children in a garden. There was also a postcard
of that mysterious painting of a dog who peers out of the
darkness into a shimmering yellow light and the self-portrait
that Goya made when he was about seventy years old, the
white shirt open at the neck to reveal the softness of his
ageing skin.

'How is Goya?' my mother asked in a voice that had
become a whispering monotone, her eyes busy in a face
that was impassive and almost without expression.

'Oh, he's fine,' I replied, very matter of fact, as if he was
a friend who lived nearby. 'I've just been reading about
him when he was eighty years old and living in France.
He wears three pairs of wire-framed spectacles, one on top
of the other like a tangle of long-legged insects, because
his eyes are so bad. He eats quantities of dark chocolate.'

'Still painting?' asked my mother, for whom painting had
always been an essential part of survival.

'Yes, he goes to the market and looks at the fruit and
the vegetables on display there and then he comes back
and makes a painting in the time that it takes him to smoke
two cigarettes. And he's making those miniatures with
black ink on little pieces of ivory, but he has not got much
ivory and so he keeps rubbing them out in order to do
another one.'

'Do you talk to him?' my mother asked me vaguely, as
if there was nothing odd about talking to a man who had
been buried for a hundred and seventy-two years.

I said yes, I did talk to him until I remembered that he was deaf and so he could not hear me. Then I sat and stared at him instead and, if I was lucky, he stared back.

3

In order to find a beginning I went to see the little village of Fuendetodos where Goya was born in 1746.

I arrived at the start of Easter Week, when that region of the province of Aragon is caught up in a five-day festival called the Tamboradas, and crowds of men, women and children gather together to beat upon drums as if their lives depended on it.

For the first ceremony, which is known as 'the breaking of the hour' and takes place at midnight on the Thursday before Good Friday, I was in a town a few miles from Fuendetodos. About five thousand people were crowded in a tight, dense pack in the town square. Most of them, even the children, were carrying drums and were dressed in long purple robes that looked slippery under the liquid light of the streetlamps. The pointed hoods of the Inquisition were thrown back to hang between their shoulders like a loose flap of reptilian skin. On some of these hoods you could see the eye-shaped holes cut into the cloth, as empty and threatening as the eyes of ghosts.

As the moment of the hour approached the crowd seemed to go through a chemical change; it solidified and became one single body, tense with anticipation. Just

before the stroke of midnight a priest on a raised platform called for silence through a loudspeaker. A few whispered hisses moved like a wind across the bobbing sea of heads. Then there was a hush followed by the terrifying sound of all those drums bursting into one long, rolling hammering of noise.

It was as if the world and everything in it had been given a single, reverberating heartbeat. The paving stones under my feet were answering the drums. The pillar against which my hand was leaning, pulsated. The door behind me trembled like a live animal. The air had become as thick as water with the weight of the noise it carried and my body was hollow and full of it.

Time passed and I became aware of an anthill ripple of activity as the first of the drummers managed to turn to face the narrow street that was the only way out of the square. They began to push steadily towards it and bit by bit the long line of a procession took shape as everyone joined in the march.

The stretched skin on many of the big drums was decorated with pictures: I saw the crown of thorns tipped red on each spike, the weeping and wounded face of Christ, a bleeding heart stabbed through by a sword. Some of the drums were also decorated with great splashes of old blood, sprayed out like the petals of a chrysanthemum. The new blood would come later when people had battered the palms of their hands sufficiently to make it flow.

The crowd was busy throughout the night, walking up and down the streets, gathering and separating and always drumming, the noise loud and anarchic with no particular rhythm to hold it steady. It was like being caught up in a battle.

I left before the dawn. Down by the river two nightin-
gales were singing among the branches of the poplar trees.
Their voices rose and sailed above the roar of the drums
as if they were the souls of the dead taking leave of the
bodies for which they had no more use.

The processions began on Good Friday. I went to a
different town a few miles further south where the people
wore robes of black, not purple. Men drinking beer and
drumming; women nursing babies and drumming; children
in their Inquisition costumes eating ice cream and drum-
ming; a baby sleeping peacefully in his pram, oblivious to
the noise, with a little drum resting on the black satin of
his gown.

I saw a thin and dangerous man, smiling with a mad
contentment as he examined the wounded palms of his
hands which were sticky with blood. I saw a mongoloid
man wiping the tears that streamed down his face with a
big white handkerchief, while beating his drum with such
fierce and heavy strokes I thought he would topple to the
ground like a felled tree. I saw a little girl dressed as
Salome, running to join the procession and holding the
severed head of John the Baptist swinging from her hand.
I saw the figure of Thin Death, carrying a scythe and shuf-
fling forward, a hood of sacking covering his face and his
serpent eyes flickering through the holes cut into the cloth.

And I saw Goya watching it all. I saw him grinning in an
ecstasy of participation because even though he was deaf
he could feel the noise seeping into the palms of his hands,
rising through the bones of his feet, and he could see it in
the contorted faces of the people, their arms flailing with
energy. He could make a drawing of the thin and danger-
ous man smiling to himself, of the mongoloid weeping, of

two old people dancing, three young girls whispering, four old men sitting in a row. He could make a drawing of the one body that is a crowd of human beings united by a single purpose. He could show that crowd when it was gentle, the men and women laughing together, taking pleasure in the sunshine. He could also show it when the switch was pulled the other way and these same people were transformed by fear or hatred into a monstrous shape, the black holes of their mouths wide open and filled with terrible noises.

4

The name Fuendetodos means 'The Fountain that Belongs to Everybody'. According to the story, a nobleman who owned Goya's village and all the land around it claimed that he also owned the water that bubbled from the side of the hill. But then a poor man said this was not true, the water belonged to everybody.

Apart from feeding itself as well as it could, the village used to produce blocks of ice made from packed snow that was stored in ice houses and taken for sale in the big towns in the summer. From the same road that passes the spring you can make your way to one of these ice houses, a beehive-shaped building that looks as forlorn as an abandoned piece from a game of chess. A path scattered with sheep droppings and alive with jumping crickets leads to the ice-house door. You push it open and a deep cold smell rushes out at you from the darkness. With my hand on the inside wall to guide me, I followed the stone steps that spiral down deep underground until I reached the circular mud floor at the bottom. The white rectangle of light from the door seemed as distant as the moon.

Goya's father was trained as a gilder, but in Fuendetodos he gave up that profession and worked on the cultivation

of patches of land owned by his wife. In 1750 they moved to Zaragoza but the family connection with the village was not broken and one of Goya's brothers lived there later.

The house in which Goya was born was restored in the 1950s and turned into a replica of its former self. It is a tiny building with two small windows at the front and one at the back. There is hardly enough room for a chair and a little table in the entrance hall, a sink and a few bowls in the kitchen and a bed in each of the three sleeping rooms.

A framed photograph taken in the 1930s shows the village schoolmaster in his classroom and nine small, solemn-faced children, related to Goya on his mother's side, standing in a line beside him. Another photograph is of a short stocky man with his hands in his pockets, next to his short stocky wife and their four short stocky daughters. Then there is an aged couple whose name would translate as Mr and Mrs Fat and whose ancestor was Goya's godmother.

Coming back one day from the noise of the drumming, I went for a walk in the low hills close to the village. The land was quiet and peaceful. Pale boulders emerged out of the pale ground. Pale stone walls flanked the old mule track that still leads directly to the city of Zaragoza some thirty miles away. The little wheat fields looked like washing laid out to dry in the sun.

I saw solitary circling eagles and a crowd of vultures. The beautiful hoopoe bird, with its powder pink face and its crest like a lady's fan, kept appearing out of nowhere and calling its own name. There were partridges running on red legs and many signs of wild pig. I could imagine Goya out hunting with a dog – he loved to hunt – zigzagging among

the pine and the evergreen oaks; the air filled with the scent of wild thyme and rosemary; larks throwing themselves ecstatically into the clear blue sky and the rest of the world far away. I could see him riding on the back of a mule, his feet in walnut stirrups and a wineskin tied to the saddle as he followed the track that would lead him to Zaragoza.

I came to the ruins of a house and realised that this must be what was left of the farm that Goya gave to his older brother Tomas, once he had accumulated enough money to make such gifts. He stayed there for several weeks in 1809. He had been to Zaragoza and had witnessed the chaos of the start of Napoleon's long war in Spain: the heaps of men and women and children lying dead and as yet unburied among the ruins of their shattered houses. Now he was returning to Madrid, but he paused in the familiar landscape before going any further: sitting with his back to a stone wall and looking out across the undulating hills and peaceful fields towards the two towers of the village church of San Antonio and the cluster of pale houses gathered around it. A deaf man in need of quiet; thinking about war and the horror that war brings.

On the next day I happened to go through a town called Belchite. The road passed two grain silos, a depot behind a high metal fence and a few desultory modern houses, but then it turned abruptly to the left and another much older road continued straight ahead and went under an ornate archway made of bricks that looked as though they had been partially devoured by termites. A little notice beside the archway explained that the old town of Belchite had suffered very badly during the Civil War and its ruins had been left undisturbed as a monument to what had taken place here and elsewhere across the country.

You enter a narrow street. The houses on either side have pretty wrought-iron balconies and the heavy wooden eaves under the roofs are carved in intricate patterns. The glass from the window frames has gone, but bedraggled shreds of curtains still hang in some of them. The doors of the houses have been violently thrown open to reveal rooms flooded with rubble and their own collapse. I saw the remains of an elegant chaise longue that seemed to be trying to escape up the steps of a shattered staircase. A palm leaf from an Easter procession long ago was still hanging across one of the balconies.

I have often in my dreams walked through empty streets and entered empty houses to see what or who they contained. This now was like walking through a dream; the buildings had become a solemn crowd of dispossessed people who were displaying the wounds the war had given them.

A tiny, wrinkled woman dressed all in black came tottering towards me, supported on either side by her grey-haired daughters. She was obviously returning to Belchite after a long absence. Perhaps she last saw it when the fires were still burning and the people were still crying. She chattered continuously as she moved through the streets, giving a name to a broken fountain, to the side of a house, to a heap of stones, while the spirits of the dead bobbed and turned around her like hungry pigeons.

Belchite had several fine eighteenth-century churches and the people must have run to them for shelter and sanctuary. But the bullets and the mortars followed them in, setting fire to the roofs, cracking and splintering the surprised faces of the angels, smashing the stained glass in the big rose windows and gnawing at the marble pillars that were veined like slabs of meat.

I stayed until the pink and yellow mist of a beautiful sunset began to drift through the skeleton of the town. The silence was broken when a group of shepherds arrived with a flock of sheep, their bells tinkling and their almost human voices calling to each other.

That night, sleeping in Fuendetodos, I had a dream in which I opened a door and a dead woman was standing there, looking at me. I closed the door and opened it again and she was still there.

Goya the deaf man makes me think of a toad. I see him with his softly ageing skin, blinking and gulping in a corner of my mind, his eyes as bright as jewels. But before he was deaf he was able to hear and before he was old he was young.

He must have been about four when the family moved to Zaragoza. They could have made the journey in a day, with a couple of mules and a cart to carry their belongings, taking their leave of the pale land and the croaking of frogs in the village pond and entering the old city surrounded by high and crumbling walls that would not be able to withstand the battering of war, when war came.

There is a photograph taken around 1900 which shows the house they lived in. It stands on the corner of a narrow street and looks bleak and naked, without even the ornamentation of a little balcony. A line of washing hangs from one of the windows and a wooden notice, like a shop sign, announces that Goya lived here. Two women dressed in black are hurrying past so fast that the camera has blurred their faces and bodies into something like a swirl of smoke.

Goya's father again took work as a gilder, but when he died in 1781 he left no will because he had nothing to

leave. Goya's mother was said to be proud to be a member of the *hidalgo*, or 'son of somebody' class, but she had no money to match her status, even though the family crest was carved above one or two of the houses in Fuendetodos. When her son the painter left home, she presented him with a notebook in which she had written the names of all the important people in Madrid and over the years he painted most of their portraits and ticked off the names, one by one.

He was sent to Father Joachim's school for the poor and there he met Martin Zapater, who became a close friend. For twenty-five years he sent letters to Zapater full of spelling mistakes, exclamation marks and doodles, full of talk of sausages and chocolate and hunting dogs and private jokes about whores and the pleasures of masturbation. He told his friend how much money he was making, how many partridges and hares he had shot, how well his life was going, how famous he was becoming. Sometimes when he was overwhelmed by the hectic demands of commissioned work, he suddenly longed for Zapater to be there beside him, in his arms, in his bed, as if the two of them were lovers. 'I am licking my fingers just thinking of you,' he said. 'I am calling you with my finger and with that same finger I am yours,' he said and he smeared a thick line of black ink across the page. Occasionally, in between the elation of so much success, he admitted to feeling unwell, unhappy, he said his head hurt, his wife was bleeding after another miscarriage, the money did not last because he kept on spending it and all his relatives were so greedy.

The friendship continued until after the illness that left him completely deaf, but around that time something must have changed between the two of them because the letters

become infrequent and less intimate. And then it came to an abrupt end because Zapater died when he was still in his early fifties.

At the age of fourteen Goya was sent to study drawing under the guidance of a man who was employed by the Inquisition as their Reviewer of Dishonest Paintings, which meant his job was to conceal human nakedness in the work of the Old Masters, using a carefully added swirl of cloth, a shadow or the floating presence of a leaf. In later years Goya made several paintings and etchings of naked men who have no genitals to conceal and people have written studies about what that might mean. They have also wondered about the picture of Saturn devouring his son in which the mad god apparently had an erect phallus that vanished when the painting was removed from the wall and fixed to a canvas. And about the man smoking a pipe while holding his penis in the other hand and the man who seems to be masturbating while two women watch him and laugh.

At the age of eighteen and again at twenty, he applied for a scholarship from the Royal Academy of Fine Arts in Madrid, but on both occasions he was rejected. He spent two years studying painting in Rome. He came back to Zaragoza and became a friend of the much respected painter Francisco Bayeu. He married his friend's sister Josefa and moved with his new wife to Madrid. At first they lived with her brother on the Street of the Watch and then they bought a house on the Street of Disenchantment.

The Bayeu family's connections helped Goya to obtain an appointment as Court Painter to the old Bourbon king Charles III, who tended to spend most days out hunting unless matters of state kept him back for an hour or so.

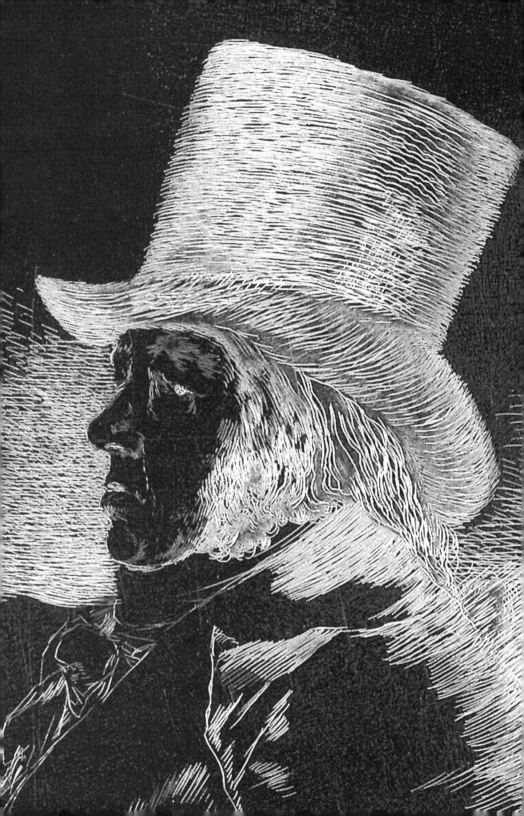

In a letter to Zapater Goya wrote, 'If I had more time I'd tell you how well the King, the Prince and the Princesses treated me . . . I showed them four paintings and I kissed their hands. I have never had such a good time. I am beginning to have more powerful enemies and more envious ones too.'

He worked for the Royal Tapestry Manufactory, producing dozens of painted cartoons of country scenes, weddings and picnics, dances and fairs, in which the images of contentment and perfection were often edged with a sense of danger. He painted a fresco for the ceiling of the Cathedral of Mary of the Pillar in Zaragoza and I looked for it when I was in the cathedral, but there were so many people eager to kiss the pillar on which the diminutive silver figure of the Virgin is standing, that I lost my concentration and left without having seen anything apart from the faces of the crowd.

Goya's portraits were much in demand. His clients liked the way he could show the quality of cloth, the value of jewellery and the glittering weight of medals. They did not seem to mind if some of their faces looked ugly or frightened or filled with despair.

At the age of thirty-seven Goya was commissioned to paint the portrait of the Count of Floriblanca. He included himself in profile: a very young-looking man with a pigtail and a snub nose, dressed in black with silver buckles on his shoes and breeches and a silver clasp at the nape of his neck. He emerges out of the darkness, kneeling before the bird of paradise apparition of the Count who shimmers in his fine feathers of red and blue and gold.

By the age of thirty-nine Goya had become Deputy Director of Painting at the same academy which had twice

refused him as a student. By the following year he was Painter to the King, which was a further step up the ladder from Court Painter. He wrote to Zapater:

> I went hunting twice with His Majesty. He is a very good shot. The last time he let me have a go at a rabbit. 'This little painter is even more keen than me,' he said. I have spent a whole month with these gentlemen and I do think they are wonderful. They gave me one thousand duros as well as a frock, all of silver and gold, for my wife. According to the wardrobe people it's worth at least thirty thousand reales.

He said, 'Seven kisses on my arse is what you would give me if I could show you how insanely happy I am to be living here.' He said, 'I am as contented as the happiest man . . . My work is appreciated.'

He bought himself a patented gilded carriage made in England. There were only three like it in all of Madrid and people stopped to stare when he drove past. But one day the carriage turned over and almost killed a man walking in the street and so he got rid of it and acquired a pair of mules instead. He asked Zapater not to tell anyone he was getting the mules, in case they laughed at him. He suspected they were already laughing.

He made a study of his family history, especially on his father's side, and finally he found enough nobility in a distant Basque relation to justify calling himself Francisco *de* Goya, which sounded better in the company he was keeping. He practised the new flourishes of his signature.

His wife had diamonds and fine clothes. He wore an English stovepipe hat which sat heavily on his head and

made him look like a rather untrustworthy businessman. He had a pair of boots especially made for him in England and was very disappointed when his feet still got wet on a hunting expedition. He had a gold watch which he lost and found again two years later. He put his money into new investments, he had good hunting dogs and guns and as much sausage and chocolate as he could eat.

But he also had poor relatives who were endlessly making demands, his investments went wrong, he had headaches and dizziness and the sensation that his head was filling with water. And although his wife was often pregnant she had numerous miscarriages and of the seven babies who were born full-term, only one survived into adulthood.

He said, 'If I have not written, I have my reasons. The Daughter I had here died and I was a bit sick myself.' He said, 'They do not leave me alone. I do not know how to cope. I am working a lot, I do not have any fun.' He said, 'My friend, I am out of my depth. My wife is ill and the child is even worse, even the kitchen maid has got a fever.' He said, 'I have suddenly become old with a lot of wrinkles and you would not recognise me were it not for my flat nose and my sunken eyes.'

And so he went on, swinging backwards and forwards between elation and despair, between energy and exhaustion, until illness forced him to sit still and silenced the demanding hubbub of the world.

6

Goya used to complain that his head was filling up with
water. There were rushing sounds in his ears, he said, and
he often felt dizzy and faint. Then in 1792, when he was
forty-seven years old, he became very ill. No one is sure
what the cause of the illness was: it might have been a
form of lead poisoning brought on by the white base-paint
that he used, or a variation of Meniere's disease, or some-
thing else. The worst of the attack lasted for several
weeks.

He recovered his strength slowly, but for the rest of his
life he remained deaf. As deaf as a house, as deaf as a stone,
as deaf as a dead man who will not be woken from his cold
sleep no matter how loudly you shout.

This was deafness of the inner ear. Something within
those delicate sea-shell cavities had been irreparably
damaged and nothing would bring them back to life again.
He could not amplify the weak signals from a voice with
the help of an ear trumpet. He could not, like Beethoven,
hold one end of a stick clenched between his teeth and
rest the other end on the top of the piano so that when
the notes were played they were channelled directly into
his skull. There were no good days following the bad days,

no remedy for his condition, no way of making it less extreme.

He had entered a place without birdsong or music, without footsteps approaching or dogs barking in the distance. Deafness is said to be the most shocking of all sensory deprivations. It locks you inside a cage and, since you cannot share the communication of language, it threatens to turn you into an idiot. The real world becomes strangely two-dimensional and empty, because nothing exists within it beyond your own immediate field of vision. You must use your eyes like a torch in the darkness and learn to read the truth from what you see and not from what you are told to see. And if the silence that envelops you becomes terrifying and people appear like so many gesticulating phantoms, then all you can do is withdraw into the privacy of your own being and wait for the storm to pass.

With one sense gone, the others must do their best to compensate for the loss, the whole body straining to catch the sounds the ears have been deprived of. The soles of the feet can feel the sound of cannonballs ricocheting against the walls of a city, of a huge crowd roaring in one voice, of the crack of thunder. The eyes can hear the sweet movement of a bird flying, a woman smiling, leaves turning in the breeze. They can listen to the silent hieroglyph of a hanged man, a sleeping child, a crowd holding its breath. Each image becomes imbued with a sonorous quality that clings to it like the melody of a tune.

I close my eyes and I am blind, but when I go to sleep I can see again. I close my eyes and I am blind, but when I let my thoughts drift the faces of people I have known, houses I have lived in, landscapes I have walked through, appear before my eyes as vivid as daylight.

But how can I know what it means to be deaf? Do the deaf dream the sound of the rush and hiss of waves breaking? Do they dream of dogs barking or piano music playing? Do they listen to voices speaking to them and wake with the belief that the power of hearing has been miraculously returned? Or do they wake like Caliban on his island of noises, crying to dream again?

Because I wanted to get closer to this idea of deafness, I bought myself a box of earplugs: little pellets of pink wax swaddled like strange eggs in a thin mist of cotton wool. You lift one out and make it warm between your fingers. You shape it to a conical point and press it gently into the ear's orifice.

Once I had closed both ears as carefully as I could, the world did not turn silent as if a switch had been pulled, but it did become very muffled. Everything took a step back. There was no ticking of the clock. My breathing became so remote it ceased to be my own. The chair on which I was sitting did not answer the shifting weight of my body with the groan and creak of wood. I did not hear the door being opened and when someone tapped me on the shoulder I was suddenly afraid. For as long as I remained even partially deaf I felt myself to be close to an unfamiliar dimension of loneliness and isolation.

I attended a class for people who were learning to use sign language. The teacher had curly eyelashes and a round clown's nose. He enunciated his words so carefully it was as if his mouth was full of some adhesive substance that tugged at his lips and stuck to his tongue. When he made signs with his hands I could almost understand what he was saying, simply because of the intensity of the gestures and the way he stared into my face.

One old man sat apart from the rest of us. He had been deaf since birth. He was wearing a garish striped jumper and a striped woollen hat. He was swaying from side to side and muttering to himself, so apparently oblivious of his surroundings that I thought at first he must be simple-minded.

People took it in turns to sit on a chair facing him, so they could practise talking in signs. Once they were there within his line of vision, he came alive with concentration and intelligence. He answered the fluttering movement of hands with his own hands, but whereas those who were addressing him kept silent, he was noisy with the effort and satisfaction of communicating. Loud grunts, groans, sighs and even a sharp and mysterious clicking, bubbled and tumbled out of him. And because he was being understood he smiled and laughed with a wild pleasure.

I once knew a deaf man. He became deaf when he was eight years old and had never learnt to use sign language but he was able to lip-read. His wife was an actress with red hair and when she spoke to him in a rapid and inaudible whisper, he could follow every word she said. I remember watching them together; how his eyes never left her, how he feasted on the movement of her lips.

And then she died and when I went to see him again his desolation was as black and thick as smoke. It was as if he was now blind as well as deaf.

We crossed a busy street together and before I could stop him he walked straight into a hooting line of traffic without pausing to look left or right. We entered a café where a football match roared from a television screen and people were shouting to each other and banging their

glasses on the zinc table tops. I can see him now, sitting on a stool at the bar, hunched and silent and closed in upon himself, like a bird of prey on a perch in a cage. I place Goya next to him, the two of them side by side.

Goya went deaf in Cadiz. He was staying there with his friend Sebastian Martinez, a successful merchant in a city full of successful merchants, the port bristling with the masts of their ships.

Martinez collected paintings and owned a number of Piranesi etchings in which men are shown trapped and helpless in dark labyrinthine prisons, the stairs leading only to more stairs and the doors never taking you back to the outside world.

In the portrait Goya made of his friend, he wears canary-yellow satin trousers with silver buckles and silver buttons and a beautiful gold-blue-green satin coat. A froth of white lace bubbles around his neck and a very neat white wig contrasts with the blackness of his eyebrows. He has an expression of tranquillity, kindness and intelligence.

Martinez might have lived on the newly built Street of Isabella the Catholic perhaps, or the Street of Humanity, or the Street of Costa Rica, in one of those tall eighteenth-century houses that still dominate the centre of the city today. Many of them have metal studs on their heavy doors and the delicate hand of a woman wearing a wedding ring with which to knock on the wood and make your presence known.

You go through into an entrance hall decorated with patterned white and blue tiles, the *azulejos* first brought here by the Moors in the eighth century. The treads of the main staircase are made from white marble and the ceilings are supported by fat wooden beams from the conquered trees of the New World.

I stayed in such a merchant's house in Cadiz, although its grandeur was very faded. The Pension Argentina it was called, the name written in neon lights that had lost their electricity. The open door on the street led you into an enclosed courtyard where a jumble of plants stood looking rather abandoned in pots. The well in one corner of the courtyard was carved from a single lump of marble, but it had been painted with so many layers of white and green gloss paint that it seemed like a huge fungus that had erupted from the floor and burst open, sticky and shining. The place smelt of neglect, olive oil and bad drains.

The man who ran the pension on the second floor wore such thick spectacles that the eyes behind the lenses were magnified into strange blinking creatures, drifting away from his face. He was full of knowledge about the city. 'Goya?' he said. 'Ah yes, he was here painting a mural in our Convent of Saint Augustine, but unfortunately he fell from the scaffolding and hurt his back.'

'This is a merchant's house,' he said and he asked me to examine the thickness of the walls and to appreciate the quality of the marble pillars. He explained that there was a layer of sand above each beamed ceiling, but at that moment my Spanish failed me and I could not understand what the sand was doing there.

The big rooms on the second floor had been divided into a warren of little guest rooms, separated from each

other by thin walls. There was just enough space for a rick-
ety bed, a sink and a tall cupboard. I imagined Goya being
here, looking out through the same metal bars on the
window and down into the same street. I imagined him
being ill in this room and then recovering.

The first bout of illness had already hit him while he
was in Madrid, working much too hard to keep up with
the demands being made of him. But he recovered suffi-
ciently to make his way down to Cadiz. He came to visit
Martinez and probably also because he wanted to sort out
a commission he had been offered to paint a mural in a
church (but not on the walls of the Convent of Saint
Augustine; it was the painter Murillo who did that many
years before and fell from the scaffolding and hurt his
back).

Shortly after Goya had arrived, the illness returned with
a new fury. He could not see, hear or speak. He could not
swallow food or drink. His body was wracked by cramps
that pulled him into a tight foetus of pain, and then, much
worse than that, came a total paralysis that froze him into
a protracted spasm of helplessness. Once, by mistake, I
walked into the wrong room in a hospital and saw a man
in a condition like that. He was suspended in a sort of
hammock and only his eyes were able to move. I felt
ashamed of seeing him, ashamed of having been seen.

Goya lay in a bed in a house in Cadiz, swamped by the
hallucinations that come with a high fever. Not knowing
if he was alive and in the hands of the Inquisition or dead
and in the hands of all the fiends of hell. Not recollecting
his own name, his place of birth, the face of his wife, or
the fact that he was by now a celebrated painter who had
made portraits of the King and Queen of Spain.

Martinez presumed that his friend was dying and wrote letters to say so. But after several long weeks, the invalid shuffled his way back from the edge of mortality and then, battered and exhausted, he waited while the broken fragments of his health returned to him.

He lies very still and becomes aware of the shadowy image of a prison hanging like a window to another world on the wall of his room. He watches the yellow light of the day shimmering behind the prison bars of the window. A black cat appears suddenly out of nowhere and settles on his belly. He strokes its slippery fur and it responds by digging its claws into his flesh. 'Just like one of those whores with sharp fingernails,' he thinks to himself as he strokes it again.

Martinez with the gentle, intelligent face has been nursing him all this time. He enters now, carrying a bowl of clear soup and a cup of wine diluted with water. He helps his friend to rise into a sitting position with cushions behind his back. He is shocked to see how the illness has aged him.

Goya, with one foot in his dreams, picks up the spoon and holds it glinting in his hand. He is fascinated by the globules of fat swimming on the surface of the soup. A yellow chicken's foot is submerged in the liquid like a drowned thing, a creature in its own right, redolent of despair. The wine spins through his head, as strong as old brandy.

The days of his convalescence continue. He feels like a traveller who has been on a long journey across many countries and oceans, but who is finally coming home. The

dangers which beset him have subsided and the landscape around him is becoming increasingly safe and familiar. The faithful hunting dogs of his five senses, which had scattered and disappeared, are returning one by one. Taste, touch, sight and smell are already here, he only waits now for the sense of hearing.

His head is filled with crackling, roaring sounds, battling together like monsters. And sometimes there is a rustling, rhythmic sweep which reminds him of waves breaking against a shingle beach. He is impatient for these inchoate noises to clarify, so that he can again recognise the babble of life in the street outside the window, the miaowing of the cat, the voice of Martinez come to wish him good morning and to hope he slept well.

But the noises that surround him remain stubbornly incoherent and beyond them he is aware of a cave of silence stretching to infinity, as huge as the night sky when the moon and all the stars have disappeared.

8

At that moment Martinez enters the room. No footsteps, no creak of an opening door, just this sudden presence looming down at him with an enquiring smile. Martinez opens and closes his mouth like a fish. He bends forward and his lips brush against Goya's right ear, so that he can feel the edge of stubble and smell the warmth of the skin.

A doctor arrives. He produces a bell, a shiny brass bell, and a wooden stick. He holds the bell dangling from a piece of string and he strikes it with the stick. He watches the deaf man's face for the miracle of recognition to take place, but there is no miracle, just a blank stare.

Goya begins to realise what has happened to him. It is like waking into a nightmare, this surfacing into a world that is still trapped under something like a lid. He pushes a finger into both ears, twisting them as deep as he can reach, as if there was a barrier that could be broken through to release a floodgate of real sound.

He speaks to himself, one hand feeling the movement in his throat, the other hovering above his mouth to touch the words as they are produced. He shouts as loud as he can until Martinez comes running to his aid and he goes

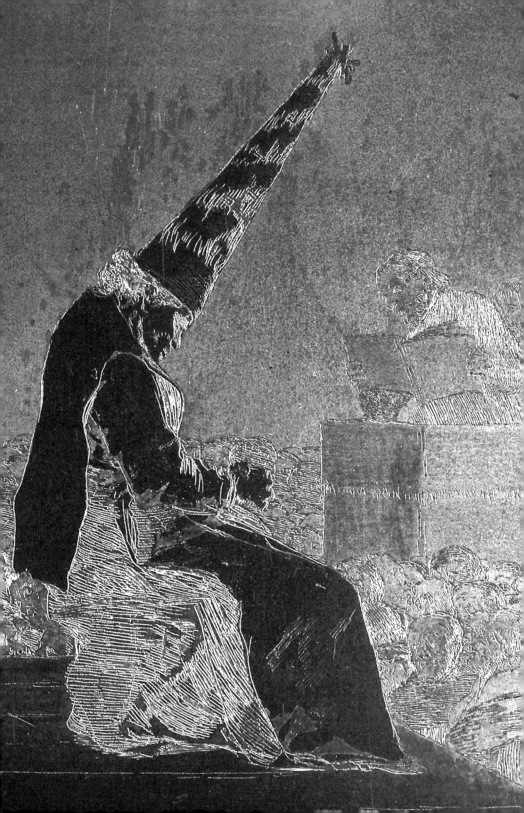

on shouting while his friend holds him and rocks him like a mother trying to calm an hysterical child.

'Will it come back?' he asks, the question groping blindly for an answer.

'I hope so,' Martinez writes in pencil on a piece of paper, and then taking the paper again he adds, 'You *must* be patient.' He underlines the word *must* several times because he feels so helpless.

By now Goya has become strong enough to dress himself and even to take a few halting steps. Martinez writes to a friend, saying that he has managed to walk down the stairs unaided.

He sits on a chair outside the front door watching the mime of daily life unfolding before his eyes. A little boy runs towards him with his mouth wide; perhaps he is screaming. A dog on a chain opens its jaws and throws back its head, the soft folds of the jowls trembling, while a glistening thread of saliva drops to the ground.

He walks arm in arm with Martinez through the streets of Cadiz. They follow the line of the fortress walls built by the Moors, each stone looking as soft as a lump of dough. They reach the edge of the sea and gaze at the silent waves crashing against the rocks. A quarrelling flock of silent gulls swoops down to fight over something that bobs and floats on the water's surface.

They set off back towards the centre of the city and they are just turning the corner that leads to the cathedral square when a team of mules pulling a heavy cart draws up behind them. The mules have red and yellow ribbons threaded through their manes and tails. Swirling flower patterns have been shaved into the glossy hair of their flanks and silver bells shake on their harness. The driver is dressed like a

bullfighter. He wears blue silk trousers and an embroidered waistcoat. His hair is tied in a long pigtail that has also been threaded with red and yellow ribbons. The clatter of hooves and the grinding of metal wheels on the cobblestones is deafening.

Just as the cart is about to pass them by, Goya turns and steps out into the street and he would have been knocked over had not Martinez managed to grab hold of him and pull him back to safety. He stands there grinning sheepishly at the jingling colours and at the mule driver who is shouting insults at him, and then he begins to cry.

He cries because he is excluded from the noise that makes things alive. He has become different from everyone else and yet that difference is not visible. He feels he should wear a placard proclaiming his infirmity, like those wooden placards hung around the necks of the men and women found guilty by the Inquisition. He remembers the trial he saw when he was a child in Zaragoza: a man tied to a chair, his bowed head crowned with a dunce's hat and his crimes on a placard around his neck and written all over his clothes; his accusers watching him from within the anonymity of their pointed hoods, the reptile eyes glittering through the holes cut into the cloth. He remembers the Easter Week processions, the men beating their drums until their hands were sticky with blood, the flagellants whipping their naked backs so that the blood splattered on the watching crowd like drops of rain.

9

Last night in a dream I was with my mother who died several months ago. We were sitting facing each other across a round table that I knew from my childhood and the sunlight was coming in through a window. I was trying to explain something very important to her, but although I kept opening my mouth to speak, no words would come.

When I woke up I remembered again with a sudden clarity the process of her dying. At first she had wanted to talk and talk, urgent with all the things that needed to be said before she was ready to leave the world. But then at a certain moment something went quiet within her. She lay there with her strangely changed face and she watched my face. Throughout the years before those final hours I had always been afraid of confronting her gaze, but now there was no threat or challenge in it, just the fact of seeing and being seen. It was as if we were having a silent conversation in which the accumulation of experiences we had shared during our lives floated up to the surface and we were able to observe them without effort.

I suppose I have often mistrusted the spoken word. You give a quick tug on the line and out they come from the dark containment of the mind, those little rafts of sound

that jostle together shoulder to shoulder and are supposed to be able to give shape to what you really think, or feel, or know. But words can so easily miss the point, they drift off in the wrong direction or they insist on providing a clear shape for something that by its very nature is lost when it is pinned down.

Perhaps that is why I have been drawn to Goya, this man who could not hear the sound of his own voice, or what it was that people were trying to communicate to him from within a gesticulating silence. Before his illness he had said how much he longed to have quiet, to be left alone, free to get on with the work that pleased him. And now his wish had been granted with a terrible precision.

The first shock of the isolation of deafness combined with physical weakness to leave him completely disorientated. 'My dearest,' he wrote to Zapater, 'I am on my feet, but so bad I don't know if my head is on my shoulders, with no desire to eat or anything else. Only, only your letters please me, and only you.'

Some months later he wrote, 'As for my health, I feel the same. At times I am in such a raging mood that I can't bear my own company. At other times, like now, I am more calm, but even as I take up my pen to write to you, I am already tired.'

He began to learn to work within the dimensions of his changed state; no longer needing to be disturbed by the disparity that can lie between what a person says and how they look when they are saying it. No longer needing to explain himself in words, or listen to the explanation of others.

10

Goya must have left Cadiz during Carnival Week in the spring of 1793. The people danced and sang. The men dressed up as women with breasts as big as melons, the women became as brazen as any man and full of obscenities and savage laughter. They carried grotesque puppet figures raised high on poles and wore masks big enough to cover their shoulders. Just before the fasting of Lent began there would be the ceremony called The Burial of the Sardine, when half a pig made to look like a huge fish was lowered into a grave and covered with earth.

The coach to Madrid followed the battered tracks of the south in the direction of Cordoba. The orange trees were already in bloom and the little tips of young grass and spikes of new barley showed as a blur of green over the red earth. But these were hard times, the harvests had been particularly poor since the revolution in France almost four years before. Everyone had noticed that the sunsets had become much more bloody than they used to be; they said it was as if the skies were bearing witness to the human chaos spreading like a disease across all the land. There was even less food than usual for the people who lived in the mountain villages of the south and during

the freezing cold of winter they travelled like migrating birds to the big cities, to crouch exhausted at the side of the roads, displaying their poverty and desperation and begging for charity.

I don't know what Goya saw or did not see on his journey to Madrid, but I have taken a few images from travel books of the time, and these I can scatter around him, to notice or ignore. First a tree. At a village without a name on the edge of the Sierra Nevada mountains, there was a big old elm tree that had been lopped and cut into the shape of a crucifix with two branches stretched out like arms and the face of Christ, as wild as a carnival mask, carved into the trunk.

Next a funeral procession in which the body of a dead girl dressed in white lay in an open coffin in an ox cart, the mourners following her like crows after the plough. With his eyes Goya could listen to the grinding of the metal wheels on rough stone, the heavy breathing of the oxen, the shrill cries of the women, the chanting of the priests.

Then suddenly six dwarfs emerged out of the mist, riding in pairs on three donkeys, and all dressed as bullfighters. They were on their way to the bullring at Seville. They carried sharp goads in their hands because their legs were too short to strike at the sides of their donkeys. They waved and smiled, showing their square flat teeth, before vanishing like phantoms back into the mist.

The coach passed a white crucifix made out of human skulls, built into the wall of a church. It passed a flock of scavenging birds swirling into the air from the body of a dead horse on which they were feeding and for a moment they were a crowd of demons, their harsh voices all the more malevolent because he could not hear them.

They stayed at an inn run by two women. One had naked feet, so deformed it was painful to look at them, the other had a black beauty spot, placed just below the empty socket of her blind eye. They stayed at another inn where a cow and her calf stood beside the table where they were eating and a child and a dog, both covered in sores, sat side by side on the floor, salivating with hunger. When they left in the morning a pig rushed out to greet the painter like an old friend, sniffing at the chocolate he kept in his pockets and dancing around him on stiff legs.

After five days of travelling they reached the barren plateau on which the city of Madrid was built. The old forests had been cut down when Philip II was busy making a navy and a palace for himself and all that was left now was a scattering of cork oak, evergreen oak and low bushes.

They entered the noise and confusion of the city. In the Plaza Real Goya watched the cries of the water carriers who sold drinking water kept cool in earthenware beakers and the shouts of the fire sellers carrying smouldering torches for lighting cigars. He watched the orange sellers and the ice sellers and the women selling their bodies. He watched the beggars selling their infirmities and the relic sellers who offered a scrap of bone from a saint's leg to mend a broken arm, or a prayer wrapped up as small as a pill, to be swallowed at night when the deadly Madrid colic was racing from house to house, killing people in a rush of vomiting and fever.

He entered the tree-lined avenue of the Prado where there was a marble fountain showing a goddess riding on the back of a lion at one end and Neptune embracing his wife and surrounded by dolphins at the other. This was where the people of the city came to flaunt their

possessions. A woman walked by with a dog that had been dyed bright pink. A coachman was wearing a livery made of gold lace. The jingling harness on a team of mules was all of crimson velvet. Goya remembered his own carriage and how the people had stared.

He stood in front of the Natural History Museum, which housed a human skull with a pair of horns sprouting from the temples; an Egyptian mummy; a dress that had belonged to the Emperor of China and the fossilised remains of a monstrous and unnamed beast found embedded in rocks near Buenos Aires: six feet high at the shoulder, with a long neck, stout legs and terrible claws.

He came to the Street of Dangers which got its name because it was so narrow a man must cower in a doorway if a carriage drove by, and then here was his own Street of Disenchantment where once four men had pursued the figure of a lovely woman dressed all in white, but when they caught hold of her and tore her clothes they saw that she was nothing but a corpse.

When I went to the Street of Disenchantment it was partially demolished. Everything was covered in a layer of thick grime. The few cafés and shops were boarded up and a half-eaten loaf of bread and a half-empty bottle of beer were set on the ledge of a smashed window, as if someone had been interrupted while eating a simple meal. Two very young prostitutes, wearing high-heeled shiny boots that reached up their naked thighs, stood talking together, but apart from them there was no one around. Goya's house had disappeared long ago; even in his time this was a poor neighbourhood.

His house was above a perfume and liquor store on the corner of the street. I would have him about to open the

door at the exact moment when all the bells of the city's churches and convents rang out together in one jangling voice, to signal the ending of the day. As soon as people heard the bells, they stopped what they were doing: carriages came to a halt, women veiled themselves, men raised their hats and waited. Goya in his deafness could not at first understand why time had been made to stand still like this, until he remembered the tradition of the bells.

I wonder if his wife Josefa knew he was on his way home. Did she hear the key in the lock, the footsteps on the stairs? Did he call out her name into his own silence and did she answer him?

It is not easy to see Josefa. Goya referred to her occasionally in passing when he wrote to Zapater: she was in bed after another miscarriage, she was in bed after a difficult birth; he had given her a dress – but never anything more personal. There is a portrait dating from the late 1790s which was once thought to be of her. It shows a pretty young woman in a blue dress, her expression both querulous and acquiescent, her hands resting in her lap, her blonde hair tied in a loose bun. But she is much too young and untouched by life and could not be someone in her fifties who had carried so many babies and had been married for almost thirty years. So that leaves only the one little drawing of her, made in 1802.

Nevertheless, let Josefa now come towards her husband, speaking to him in a voice he once knew well. She has also been very ill during the last year, so they can recognise the suffering in each other's familiar but altered faces. Their twelve-year-old son, Javier, can be there too and the three of them can embrace.

Goya is still weak and easily disorientated. He gazes

wistfully at his wife and child as if he cannot immediately recollect who they are or where he has seen them before. He wants to avoid speaking because of the shock of not being able to hear the sound the words make. He smiles apologetically. It is so odd to realise that there can be no talk about what has happened during the recent months, and how drastically things have changed.

11

One room in the houses of my childhood was always permeated with the pungent sweetness of the smell of turpentine and linseed oil. Empty jam jars were filled with brushes like bunches of dead flowers that had lost their petals. Scraps from summer skirts and dresses were torn up to be used as rags that stiffened into miniature mountain ranges. Tubes of paint lay twisted and contorted in a private agony. Palette knives and palettes were made ancient by the splattering of layers of dried paint. A tray filled with bottles of rainbow inks was next to a human skull stained yellow by the earth in which it had been buried, next to a horse's skull that was as huge and clean and white as an angel's wing.

For a number of years during a time when she was very sad and her life was very chaotic, my mother wanted her paintings to speak on her behalf and give shape to her worst fears. She would cover a canvas with a wild soup of colours and then she would search for signs of life, allowing whatever terrifying images were lurking there to emerge and make themselves known. Suddenly a screaming man would hatch from one dark corner of the canvas and divide his body in half like an amoeba. Two naked

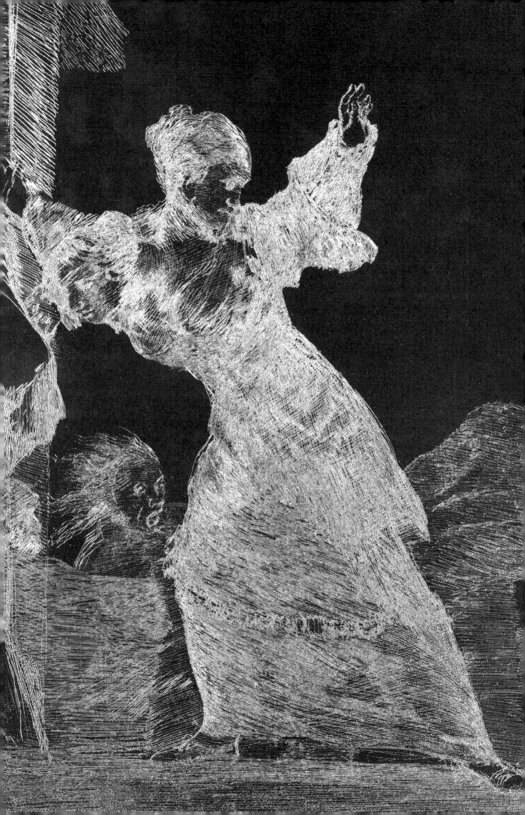

figures sat side by side in a yellow desert and howled. A woman with a headdress made of horns did not notice the rat climbing out of the box behind her, its whiskers twitching.

As a child I was sure that when the door of this room was closed then everything that lived here would begin to chatter and fidget in a cacophony of mysterious voices, a blur of movement. I would creep in as quietly as I could in order to catch them unawares. I would stand as still as a statue and wait for the brushes to dance, the tubes to pulsate, the skulls to blink their eye sockets and the faces in the paintings to meet my gaze and speak.

Goya was back on the Street of Disenchantment and in the studio that had lain fallow for such a long time. He looked at the canvases that had been stacked against the walls and turned some of them round to face him. He pressed the stiff bristles of a paintbrush into the palm of his hand and twisted it slowly, feeling it move like a living thing. He began a series of cabinet paintings that were done primarily for himself, 'to occupy my mind mortified by illness' was how he explained it in a letter. He used small pieces of tin cut with scissors to roughly the same rectangular size and on them he built up layers of brown underpainting from which pale, glimmering human forms emerged out of the darkness.

There is a fire and no one can hope to escape; a ship-wreck that leaves the survivors stranded on a rock in the fierce wide ocean; a group of sinister travelling players whose faces are masks and whose masks are faces. There is an assault by bandits on a coach in the mountains and

everyone has been killed apart from one last man who is about to die. There is a scene in a lunatic asylum.

It is thought that Goya's aunt and uncle had been inmates in the Zaragoza asylum for a while and the painting was based on a childhood recollection. The lunatics are in a yard that is dark and yet illuminated by a drifting light coming in through a barred door and down from a colourless sky overhead. Two men dressed in rough shifts catch you with their wild stares, pulling you into the space that holds them prisoner. Two naked men wrestle together, while an attendant stands close by and prepares to separate them with a blow from the curved whip he holds in his hand. Everyone here is helpless, trapped within the thick walls of the building. Some are rocking backwards and forwards in a daze of isolation; others mutter incoherently to themselves. They are all deaf to the world.

12

age 50

Goya was back in the south of Spain in 1796. He was still suffering from the aftershocks of his illness and yet he needed to make a living. He wanted to do more portraiture and more work of his own invention.

I see him moving through the streets of a southern city, passing from the sharp blaze of sunlight into sculpted pools of shadow. The deafness has affected his balance, making him walk with hesitant, awkward steps; he steadies himself with a hand against a wall, he stands wavering on his feet. He is easily frightened by the way people erupt into view as if they have dropped from the sky, the way they rush in a silent torrent around him, whisper and laugh, creep up behind him and breathe on his neck. Everyone seems to mock his vulnerability except for those who are themselves vulnerable: the cripples, the very old, the mad, who immediately recognise him and accept him as one of their own.

It is thought he went to Cadiz to make arrangements about a commission for a church painting and to Seville to visit a friend who was also an art collector. It is possible that he was in Seville during the time when one of his patrons, the Duke of Alba, was dying, or during the days

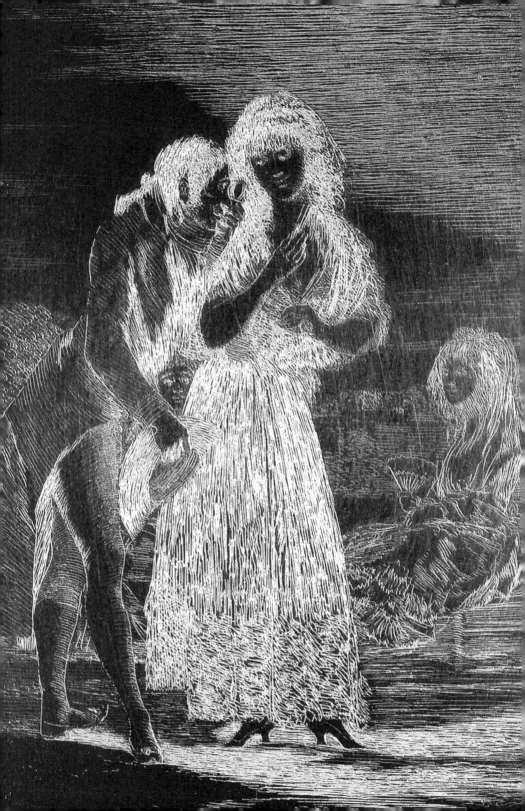

immediately after his death. If so then that would explain how he met the newly widowed Duchess and came to accept an invitation to stay with her at her farmhouse on the estuary of the Guadalquivir River.

Maria del Pilar Teresa Cayetana de Silva, the thirteenth Duchess of Alba, had thirty-one Christian names. She owned seventeen palaces and vast tracts of land from Avila in the north to Doñana in the south; it was said that she could walk the length of Spain without ever stepping off her own estates. Her family was more wealthy than the Bourbon kings, but she was the last of an ancient line; she had no uncles or aunts, no brothers or sisters and no children of her own and when she died of a mysterious wasting disease it was presumed she had been poisoned by order of the Queen, Maria Luisa.

She had the feet, hands and face of an exquisite china doll. Her waist was so tiny a man could clasp her round the middle, the tips of his fingers touching. Her dark hair cascaded in a torrent of curls down to the small of her back like a physical embodiment of the burden of wealth, beauty and power which she must always carry with her.

After the death of her father when she was eight years old, she was brought up for the most part by her grandfather, the twelfth Duke. They shared the same perfectly oval face and the same arched eyebrows that gave them a look of permanent surprise. He had a crippled dwarf called Padillo who had been tortured by the Inquisition and who would hobble beside him carrying his master's medals pinned to his own deformed chest. Later she too had a dwarf, whom she called Love.

The Duke was a close friend of Jean-Jacques Rousseau, and his granddaughter was given a liberal education and

was brought up in the Rousseau mould, despising conven-
tion and believing in the romantic ideal of natural inno-
cence and the noble savage. She learnt what she knew
from the people she met and from the books she read in
the Piedrahita Palace where the walls were lined with silk
and damask cloth.

At the age of twelve she was married to the Marquis of
Villafranca, a sombre and isolated nineteen-year-old, who
agreed to take on the Alba name, and who played the knee-
fiddle and collected clocks. The Duchess's mother decided
to remarry at the same ceremony, taking as a new husband
the aged father of a young lover who had recently died. I
try to imagine the strange theatre of this double wedding.
I see the two teenagers standing side by side, looking old
and stiff with formality, while the other two are giggling
together as if they were the children with all of life ahead
of them.

Already from the early years of her marriage, the young
Duchess had begun to collect outcasts who did not belong
in society for one reason or another and on whom she
could pour her love and devotion. As well as her dwarf,
she had the constant companionship of Brother Basil, an
old, lame, stuttering monk. She provided him with a docile
mule so that he could go riding with her. One day when
she was out with a large party she suddenly realised he
was not at her side. She turned back to search for him and
found him floundering in a muddy ditch, with onlookers
laughing and taunting him and no one offering to help.
When he was heaved out of the mud she took him in her
arms, covering him with kisses. Turning to her husband
and the others who had gathered to watch she said, 'This
friar and I are the only good people here. I understand

him. I knew from the first day that he had a soul like mine.'

Later the Duchess looked after a little black girl whom she would nurse on her lap like her own child and whom she called Mary of the Light. Luisito, the young son of her estate manager, was given the task of carrying her perfume and make-up for her wherever she went and when she wrote him a letter she called him the 'beloved of her life' and her 'own dear son'. There was also the idiot Benito, a black woman called Trinidad and an old woman known as the Blessed One because she would never stop praying. And I suppose it could be said that for several months a painter, who was still recovering from the shock of becoming deaf, was taken on as another member of this circus troupe of misfits.

They had probably first met in the late 1780s, through Goya's association with another powerful family, the Osunas, who bought a number of paintings from him. In 1795 he made a portrait of the Duchess's husband leaning wearily against a square English piano and holding a sheet of song music by Haydn in his hand, and one of her, dressed in white, standing in an open landscape, the sky as blue as a vision of heaven and a miniature white dog at her feet. The red ribbons tied in her mane of hair, pinned to her breast and tied tight around her waist, mimic the little red ribbon attached to the dog's hind leg. She stares out from under the weight of her hair with an expression that mixes innocent naivety with a haughty self-assurance.

The Marquis of Villafranca was thirty-nine years old when he died, killed, so it was rumoured, by the enthusiasm of his doctors. Goya made a drawing which looks like him on his deathbed, attended by two sinister donkeys in

white doctors' gowns and with the tiny and desolate figure of the Duchess perched on the edge of the bed between the animal bulk of their bodies.

She was often apart from her husband pursuing her own pleasures and had been in Madrid during the months preceding his illness. But she might have got to Seville in time to share his final hours or to see his cold embalmed body before it was consigned to the Alba family vault. As soon as the necessary rituals were completed she went to her house at Doñana.

It might be that she met Goya at the deathbed or at the funeral or perhaps she wrote to him once she was ensconced in that solitary retreat, surrounded by the noise of birds. Anyway, she summoned him and he was obedient to her command.

I see him travelling in a little carriage pulled by mules across the flat landscape of that region. A dog barks as he approaches the house; maybe it is the absurd white dog that consented to the indignity of having a ribbon tied around its hind leg. A servant calls out that the carriage has arrived and another servant answers. The starlings are singing like mad things, perched in a dense line along the tiled ridge of the roof.

The carriage is led into the central courtyard where the floor is paved with narrow bricks that seem to tremble with the movement of their own broken lines. A crowd of potted plants are gathered around the elephant leg of a tall palm tree. There are doves bobbing and cooing in a dance of courtship. A cat disappears through an open door.

Goya must realise in these first moments that he has come to a quiet place and he has a great need of quiet, in spite of his deafness, or even because of it. The Duchess

appears at a window. She leans over the metal balcony dressed only in a white shift, her black hair pouring in a torrent over her shoulders. Her chambermaid Catalina is beside her. The two of them have such a similar build they could easily pass for sisters. They welcome him with their smiles and he enters the house.

13

Sometimes, in the moment when you are confronted by the reality of the place they once inhabited, people come alive with a logic of their own. You see them in the garden, talking, quarrelling, laughing together. You see them in the house, moving from room to room, looking out of a particular window at the sky in the first light of dawn, the sky on a summer's day unblemished by a single cloud, the sky at night.

I had imagined the Duchess of Alba's house at Doñana to be grand and intimidating. I had anticipated the apparition of an eighteenth-century palace, painted yellow and white perhaps, with marble lions to guard the steps and marble torches flaming from the top of an icing-sugar façade. I had thought of bushes cut into careful shapes, of peacocks screaming and an ornamental lake swimming with golden carp old enough to have eaten bread from Goya's hand.

Instead I found a simple farmhouse at the end of a long sandy track; a few trees, a view of the estuary and a sense that this was a place that would make no demands on a person and would allow any number of layers of unease to drop away.

The house is now at the centre of a carefully protected nature reserve that is one of the last homes of the European lynx. Even with my passport, a letter of introduction and an invitation to arrive at a certain time, I had to wait at the high metal gates while officials discussed my presence over their walkie-talkies. Then I was allowed to enter an almost featureless landscape: a flat plain in all directions and the same low bushes growing everywhere, their grey-green leaves occasionally illuminated by delicate yellow flowers which I at first thought were butterflies. A pair of white-headed eagles spiralled up into the sky.

The track crossed through a forest of umbrella pines and then there was the house, close to the water's edge. A group of eucalyptus growing near to one of the white walls looked as though they had taken several hundred years to reach such a majesty of size, but I was told they were planted in the 1900s and so I had to take them out of the picture. But I could keep the old locust tree, huge and gnarled and dangling clusters of those long sweet bean pods that pigs love so much, and an ancient cork oak, its unharvested bark cracking and splitting as if the tree inside was trying to break free and stretch into a new form. Two trees bearing witness to another time; along with the sunlight on the shallow water, the clumps of reeds, birds and insects and the house itself.

The ground was littered with dung beetles. I have never seen so many: dead ones and live ones pretending to be dead, some pushing at the weight of a ball of dung bigger than their own bodies, some locked together, mating or fighting, others setting off on obscure adventures, their rhinoceros horns bristling with defiance. I picked one up to feel the clockwork movement of the waving legs, the

grip of the feet, the determination contained in such a small thing.

The sand around the house turned to mud as it drew close to the shallow tidal waters of the river and this mud was marked with a tracery of little eddies and tinged red from the samphire that grew there. Over towards the west, umbrella pines and low bushes came down towards the water's edge. The sky was a milky turquoise.

I realised that I was looking at the background to the portrait Goya made of the Duchess, dated 1797. She is standing on this sand with the river behind her, the red of the samphire, the eddies in the mud, the trees. She is dressed in the black of mourning, but with a bright red and gold sash tied tightly around her waist, pointed gold shoes and a golden bodice that glitters through the lace like the final moments of a sunset.

The Duchess in the portrait is as light and gaudily feathered as a bird. It would not be surprising if she flew into the air, and if she walked with careful halting steps across the sand, you feel her little shoes would leave a trail of bird's footsteps.

She is imperious in her gaze and yet she looks as though she might at any moment switch over into wild laughter. She is sophisticated and childlike, defiant and helpless. She points with the index finger of her right hand at the words *Only Goya*, which have been drawn into the soft sand. Did she write that, or did he? And what made him remove the word *only* with a thin layer of paint not long after the picture was completed so that it was only discovered years later when it was being restored? His name appears again on the ring she wears on the pointing finger and 'Alba' is on the ring that lies next to it.

As I was looking at this empty expanse of land and water and at the fragile shifting image of a woman projected upon it, I became aware of the noise of birds. Thousands of glossy starlings had come to settle on the roof of the house and the branches of the trees and they were burbling, whistling and whooping. Then there was the creak and swish of swans flying low overhead, the gaggling of wild geese, the panicky cry of the moorhen, the lament of oystercatchers, the crowing of a cock, and I could suddenly hear the shimmering figure of the Duchess beginning to laugh because of this absurd, almost deafening chorus of sound. And Goya is laughing with the contagion of her laughter, although he cannot be sure of its cause.

The two of them were here together with the noise of birds, the rustling of reeds and the intimacy of silence and isolation for how long? Seven months certainly and it could have been more.

Goya must have always made drawings. In 1775 he wrote
a letter to the landlady of an inn in Zaragoza in which he
referred to himself as 'the young painter from Fuendetodos
who scribbled on the tables and the walls', and in the letters
he sent to his friend Zapater he sometimes included wild
doodles in which eyes and noses, a cup, a dog, a woman's
vagina, a man's buttocks, a gun, float like surreal balloons
among the written words. But apart from the Italian sketch-
book with its copies of Old Masters and a few preparatory
drawings for paintings, nothing else has survived until the
time when he stayed at Doñana and filled a little note-
book with a series of beautiful pen-and-ink drawings. They
are like a visual diary which seems to describe the Duchess
and her servants and the life they were leading. The
Duchess sits with Mary of the Light cradled on her lap,
the darkness of the little girl's skin answered by the dark-
ness of the woman's hair. The Duchess, or someone very
like her in build and proportion, leans out of an open
window, dressed only in a white undergarment. She bends
forward to pull up a stocking in a gesture of infinite grace.
She lies under a thin sheet with her knees raised. She
dances, she weeps, she adjusts her hair while being

watched by another woman lying languorously on an unmade bed. She writes a letter, she sweeps a courtyard.

The mood flickers and changes from joy to sadness, from maternal tenderness to a gentle eroticism. Occasionally there is an edge of sexual danger. The Duchess, or someone very like her, looks over her shoulder with a face that is a grinning carnival mask and she lifts her long skirts to reveal her bare bottom. She sits naked with her back to us, one hand sliding between her thighs while two sinister old men stare at her. She swings her body out of bed and another naked woman leans against her, so that the two seem to be joined like Siamese twins, each looking a different way.

It was midsummer. The white curtains hanging lifeless in the still air. The need to move stealthily in order to avoid the sticky embrace of the heat. The relentless whirring of the cicadas. Pine cones bursting like distant gunshot. The cry of a bird. The smell of the sea and the smell from the marshes combining into a mixture of sweet and salt as intimate as the smell of lovemaking.

Everywhere she goes the Duchess is followed by children who are not her own. Luisito and Mary of the Light cling to her skirts. Pepito the foundling follows her like a stray dog longing for a new owner. And there are others, a stream of small children all waiting their turn and eager to show affection.

The deaf painter is the latest addition to the Duchess's family. She welcomes him. She leads him excitedly along the corridors of the house from room to room, past windows that look out towards the enormity of the river's estuary

and the sea and past windows that look into the enclosed containment of the courtyard, the rows of starlings always busy on the rooftops.

She calls for her maidservant Catalina, whose face and body are so like her own. The two of them lead Goya by both hands. They laugh together as if they were children with a new playmate, whores with a new client.

They walk out into the sunlight of the garden. The old woman Eufemia, the Blessed One, dressed all in black with a white cap on her head, flaps into the distance like a big awkward bird. Brother Basil steps tentatively towards them, weaving his way between the tufts of reed that grow on the sand. He is crippled with age and his stuttering mouth struggles to produce the shape of a greeting. The idiot Benito is crouching in the shade of the locust tree, watching the dung beetles. The dwarf whose name is Love leaps out at them from behind the splitting trunk of the cork oak.

'Look!' the Duchess cries delightedly, turning to Goya who is mesmerised by the movement of her lips. 'Look, here is Love: I thought I had lost him, but he was only hiding from me. Dear Love, how I have missed you!'

'And look,' says the Duchess to anyone who cares to listen. 'Here is the painter, the famous painter Francisco Goya. He has come to stay with us. And he cannot hear a thing! Not a word! You must speak to him in signs, or write messages on the sand with a stick. Or not speak to him at all, but watch him and let him watch!'

With that she turns and puts her arms around him, pressing her little body lightly against him and covering his tired face with butterfly kisses, just as before she kissed Brother Basil when he was pulled out of the ditch.

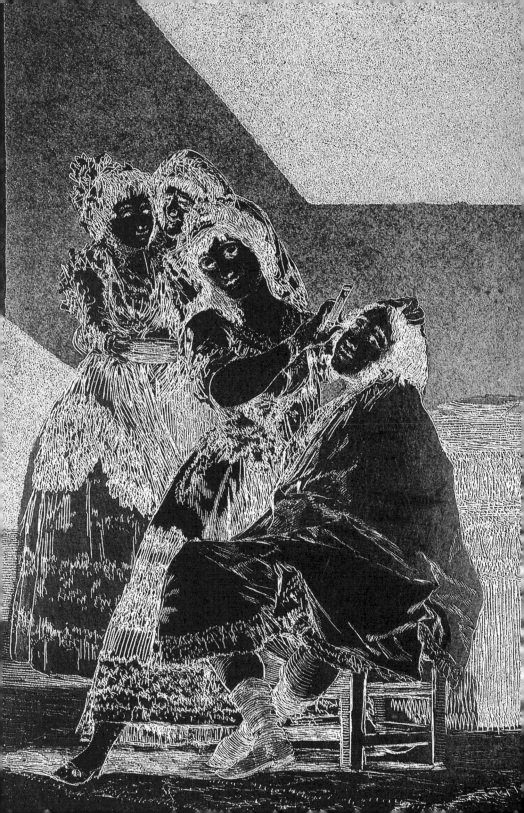

* * *

It is almost irrelevant to wonder whether Goya had an affair
with her. Some say he did and others are sure he did not.
There is no proof of anything beyond the fact of the inti-
macy of the drawings he made of her while he was at
Doñana, and the bitter sexual rage which roars through so
many of the images he made of her later, when he was no
longer in her company. Perhaps it was because of her inno-
cence that she let him watch her dressing and undressing,
waking and sleeping. Or perhaps she invited him to share
her bed and to listen to what her body had to say in the hot
dark silence.

One night I would have him caught in a nightmare and
dreaming that he is blind. People with the faces of monsters
and monsters with the faces of people crowd around him.
He can feel the deformity of their noses, their eyes, their
mouths, their ears, but he can see nothing. He knows he
was screaming when he woke, because of the pain the
sound made as it tore at the back of his throat. The Duchess
tries to comfort him, but she is afraid of so much fear.

Goya had left Doñana before the winter of 1796. He
might have stayed with his friend Sebastian Martinez or
he might have rented a house of his own in Cadiz. He was
definitely back in Madrid by 1 April, when he gave in his
notice to the academy, saying that the severity of his deaf-
ness made it impossible for him to continue his work as a
teacher.

He started a new notebook in which the first thirty-nine
pages were all drawings of women. These women have
long dark hair, small pointed feet and tiny waists. They
whisper secrets to each other. They are dangerous and

deceitful, eager to betray their lovers and sell their bodies. Men cluster around them like flies. Terrible things happen. The shadows of the world creep and slant on all sides and the uncertain darkness is brimming with danger.

15

In February 1797 the Duchess of Alba sat down to write her will. She allocated her entire fortune to people who were in no way related to her, either by blood or class. To Carlos, a childhood friend, to her estate manager, to the two family doctors she had trusted, her maidservant Catalina, the idiot Benito, the black woman Trinidad, to Mary of the Light and Luisito who carried her make-up and Pepito the foundling. To numerous other children and to the poorest of her servants.

The last beneficiary on this long list was Javier, the twelve-year-old son of 'D. Francisco Goya'. He was to receive the sum of twelve reales a day for the rest of his life. It was the only occasion on which her side of the relationship with Goya was referred to at all.

It was said that soon after Goya had gone, she began an affair with the bullfighter Pedro Romero. She gave him a tight sequinned costume which he wore when he was fighting in the ring. Then she had an affair with the Queen's favourite, Manuel Godoy, who was known as the Sausage Maker. And with others. She apparently married a field marshal called Antonio Cornel just before her death, but

never got round to writing a new will which included him.

She died in July 1802, carried off by a wasting sickness. She was thirty-nine years old. The obituary in the *Gazeta de Madrid* praised her gentleness and kindness, her noble generosity and her charity. Within a week of her death, Queen Maria Luisa was wearing her rival's pearls and diamonds as if they were trophies she had won in battle. Godoy was given the use of her palace in Madrid and he took possession of her collection of paintings, which included the *Rokeby Venus* by Velazquez and perhaps the *Naked Maja* by Goya, whose soft and voluptuous body was supposed to be hers although the face belonged to someone else. It was almost forty years before the estate was distributed to the chief heirs named in the will, and by then most of them were dead.

Goya watched it all from a distance. He kept his silence and talked to himself in images. In one of the *Caprichos* etchings the Duchess can be seen with a butterfly sprouting from her head, her arms outstretched and her black shawl spread like wings. She is being carried through the air on the back of three crouching men, one of whom can be recognised as the bullfighter Pedro Romero. There is no trace of violence or triumph in her face; she looks as if she is being swept along by a destiny over which she has no control.

In the drawing and the etching called 'Dreams of Lies and Inconstancy', she is a double-headed creature, turning one face towards Goya who clasps her tenderly in his arms, while the second face stares abstractedly into the night sky. A double-headed woman lies across her lap and offers her hand to a new lover who is approaching on his knees, holding his finger to his lips. Again a butterfly

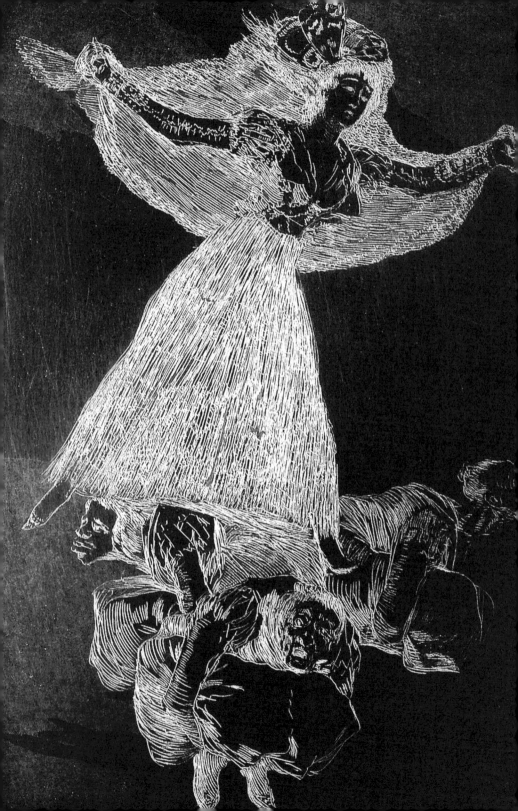

sprouts from the Duchess's head. A snake and a toad stretch open their mouths to swallow each other. A mask with a drooping phallic nose is propped between two saddlebags. In the murky distance you can see the outline of a castle that looks as if it has been carved from sand. It is a nightmare from which the woman cannot escape.

When the Duchess died, Goya mourned her loss in a drawing he made for a sepulchre that was never built. Her limp body in a white shift is being lifted into a tomb by three figures dressed in white, their faces hidden so deep within the folds of their hoods that you could think they had no faces at all. She looks exhausted and yet serene, as if she is is glad to be taken from the world.

Talk about the cause of her death continued from one generation to the next. In 1945 her remains were exhumed in order to ascertain once and for all if she had been poisoned and to compare the structure of her bones with the soft flesh of the *Naked Maja*. A photograph was taken of her, showing a reptilian skull, partially covered by old skin, peering out from a swirling tangle of disintegrating cloth.

Three doctors performed the autopsy and decided that she had died naturally from a lymph infection, followed by encephalitis. And yes, the proportions of her skeleton could be made to fit into the body of the painting known as the *Naked Maja*. There were plans to publish these investigations in full, but this never happened.

The three doctors also discovered that the Duchess of Alba had no feet. In 1843 she had been disinterred in order to move her to the San Isidoro Cemetery in Madrid. Apparently the new coffin provided for her was

three and a half inches too short and so the problem was solved in a simple and practical way. The severed right foot was placed at her side, but the left one had disappeared.

16

etching
printing

A friend has lent me an old copper etching plate. The stamp on the back says it was made by J. Borel, metal planisher, Montparnasse, Paris. It has finely bevelled edges and I can just hold it in the stretched palm of my hand. The surface is without scratch marks, but it shows signs of time and neglect in the mottled landscape of discoloration that spreads outwards from one corner.

When I polished the plate with Brasso, the unblemished areas came alive with a soft orange-pink glow. I propped it up like a mirror and stared into it. Whereas a silvered glass mirror throws back a reflection without a moment's hesitation, the copper seemed to take possession of the image of my face, holding it inside itself.

In 1797 Goya bought about sixty etching plates that must have looked very like this one, all cut to the same size with their edges made smooth and individually wrapped in cloth or newspaper.

He takes one and places it, naked and shining, on a piece of felt. He strokes the cold surface with the tips of his fingers. He breathes on it and rubs away the mist of his breath on his sleeve. He searches for any tiny indentations made by the mark of a hammer, any hair-thin scratches.

As he stares into the metal his own face seems to rise to the surface like some creature coming up for air. He feels the contentment of setting out at the start of a long road. He feels the energy of the drawings preparing to overflow into the energy of this other medium.

The studio has been made ready for the change. A pile of little glazed pans stands next to the charcoal brazier. An earthenware basin is filled with water. A bunch of tallow candles hang by their wicks from a hook on the wall. The shelves are crowded with pots and bottles, all carefully labelled. Two types of varnish, hard and soft, are next to the sulphuric acid, vinegar, ammonia salts, ordinary salt and the powdered lees of turpentine. A clothesline stretches across the ceiling, hung with little pieces of white muslin that will soon be black. A window is open in preparation for the acrid biting stink of the acid, the fumes from the turpentine, the smoke from the tallow candles, but there is no breeze entering the room. It was said in those days that the air in Madrid could kill a man but was not capable of guttering a candle.

There must be a small hand press somewhere in the studio as well, its rollers still clean. The design has hardly changed since the idea of printing an image from metal to paper was first invented in the fifteenth century. Goya thinks of Rembrandt. He has a collection of Rembrandt's etchings that were given to him by a friend and he listens to what they have to say to him, just as someone else might listen to a poem or the reasoned argument of a philosophical debate. Sometimes the pictures speak to him of such deep things that it brings tears to his eyes.

He is wearing spectacles. He cleans the copper plate with water and a whetting stone and then again with

pumice and charcoal powder made from beechwood. He rubs on a dab of ink with his finger and wipes the ink away with a scrap of muslin cloth to see if any fine scratches can be discerned. He takes the plate to the window and holds it at an angle to the light. The surface is clear of any blemish. He polishes it with a few drops of oil, humming to himself the words of an old song:

I went to the sea to get oranges,
But that is something the sea does not have.
I returned soaking wet,
Battered this way and that by the waves.
O, my sweet love.

He blows life into the brazier. He takes down a bottle filled with Florentine varnish made according to Bosse's recipe and he pours some into a glazed pan, heating it over the glowing charcoal, smelling the sharpness of the resin, the sweetness of the nut oil.

He warms the copper plate and pours a puddle of the honey-golden liquid on to it, spreading it in a thin layer with a spoon filled with flocks of cotton and wrapped in a cloth.

He leaves the studio abruptly and goes to the kitchen to eat bread and strong sausage from Asturias. He holds one side of the mill-wheel loaf against his belly and slices into it with a knife, like a peasant. When his son Javier enters he stuffs the loaf under his shirt and staggers around the room groaning as if he was about to give birth. He holds the sausage to his face like a long red nose, then dangles it obscenely between his legs. His son laughs at the jokes and he laughs too, aware of how laughter splits his face

wide open at the mouth, turning it into a grotesque mask.

He returns to the studio. He takes the self-portrait done in red chalk, in which he is wearing a top hat and seen in profile. He rubs the back of the drawing with the same red chalk and places that on the varnished plate. He follows the lines of the drawing with a steel point, careful not to pierce the paper. He removes the paper and there he is.

He uses the steel point to draw over the chalk lines and into the varnish, being careful not to scratch the plate itself, not yet. All the lines are broken, a rhythm of movement; the solidity of the big hat, the curl of the hair, darkness in a calm sea around the profile, an urgent sweep of shadow behind the shoulders.

He changes the expression on the face. The single eye that was staring forwards is now glancing sideways, watching the man at work, just as later it will watch the viewer.

When he has gone as far as he wishes to go with this stage, he fills a wooden dish with the smoking acid mixture, and immerses the plate in it, using wooden tongs so as not to burn his fingers. The liquid fizzes and steams as it bites into the metal. He lifts the plate out and uses a goose feather to wipe away the bubbles that cling to the exposed lines of copper. He uses a magnifying glass as well as spectacles, reading the depth of the bite. He submerges the plate in the acid again, takes it out, examines it, seems satisfied.

Now to remove the varnish with charcoal made from willow and mixed into a paste with water, rubbed gently over the copper until the metal looks dirty. Then acid diluted with two parts water. And rubbing and polishing and holding it to the light to see the tracery of lines that has been made.

He uses Rembrandt's technique of painting acid directly

on to the plate with a brush to achieve the effect of drawing with diluted Chinese ink. He uses dry point to enlarge the traces not made sufficiently clear by the acid and a tool called a burin to make wider, rougher lines.

For the shades of broken grey light which give him so much pleasure, he uses aquatint. He has a little cloth bag filled with a fine powder made from the lees of turpentine and this he taps over the areas which he wants to have covered. He heats the powder so that the resin melts and congeals. Then he immerses it in the acid which bites through in tiny broken dots.

More aquatint, a few more lines cut directly into the metal. Polishing one area to make it so smooth that the ink will not hold to it at all and scraping another to create a thick darkness, stopping out areas with varnish when the acid there has bitten deep enough, moving round and round from one detail to the next.

The air is filled with the smell of resin and ammonia, of acid and charcoal, of tallow candles and sweet oil. The intensity of the work is turning him into a somnambulist. He wakes with the recollection of what he left unfinished the night before; he goes to sleep with the plans of what he will do in the morning buzzing around him like flies. Day after day his head is filled with an image in reverse, a complicated explosion of lines that will only become clear once the process is completed.

When the first state is ready, then he must coat the rollers on the press with the thick ink made from lamp black. He wears gloves to protect the purity of the paper as he sets it in place on the plate. He turns the heavy wheel that moves the two rollers, clamping the metal and the paper against each other in a tight embrace.

He must be infinitely careful when he peels the paper away from the plate, so as not to smudge it. He carries it to the window, adjusts his spectacles, then gazes at the picture he has brought into existence.

The appearance of his hands is changing. Each fingernail holds a black crescent of ink. The tips of the fingers have a deathly pallor because they have been stained yellow by the action of the acid. The skin is dry. The lines on the palms marking the length of a life, the nature of a mind, the role that fate has to play within the time that is allocated, all these lines are etched in black, as if the hands themselves were waiting to be printed.

There is a mask on the kitchen table. It is a dark red plastic mask made in the traditional *commedia dell'arte* style, with a long curving beak of a nose and a thick fold of imitation skin across the forehead and around the holes that are the eyes.

Even when lying on its side in the daylight next to a vase of flowers and today's newspaper, the mask has a malevolent presence. I don't like having it in the house. I feel it might at any moment blink one of its empty eyes and say something in a sour voice, regardless of the fact that it has no mouth with which to formulate the words. And at night it might decide to creep up the stairs to enter the room where I am sleeping, settling on my face like a bird, holding on with sharp claws, refusing to let go. I consider shutting it up in a box and burying the box deep in the ground. Foolish thoughts.

I put on the mask and go to confront the mirror. The eyes that look back at me have become strangers, gazing out from the imprisonment of the shining plastic which encircles them. My mouth and chin are almost lost behind the savage curve of the nose. The transformation is so simple and easy and so devastating in its effect.

I raise the mask until it nestles in my hair, the nose pointing its accusatory finger at the ceiling. I have become two-faced. I shift the mask round to the back of my head and with the help of a second mirror I can see a new and horrible creature that has hair growing inside the cavities of the eye sockets.

I remove the mask and the spell is broken. I again turn the pages of the paperback edition of the *Caprichos*, or 'foolish things', that has been with me for so long. Here is the woman who wears a black mask over her eyes and nose, while a hideous and grimacing second face is fixed to the back of her head. And here is the woman whose features are hidden behind a sheep's-head mask and the mask of an old man is on her lap as if it has sprouted there, the nose like a huge penis. A man with the face of a bird rides a bear with the face of a donkey. A rat in monk's robes is in the company of a judge with closed eyes. The dead come alive while the living look as though they are already dead. I remember once seeing a woman who had been beaten by her husband and she walked into the room with both her eyes so swollen and bruised that her face had become a mask. I remember a nightmare I used to have when I was a child in which chanting heads were growing from the stumps of trees, a whole terrible forest of them.

Now I am looking at a book of modern photographs, called *Hidden Spain* by Cristina Garcia Rodero. It is filled with images of saints' days and carnivals, of Easter processions and burials, marriages and bullfights, but all taken from small remote villages where few foreigners ever go.

A man stands on the side of a dirt road. His face is

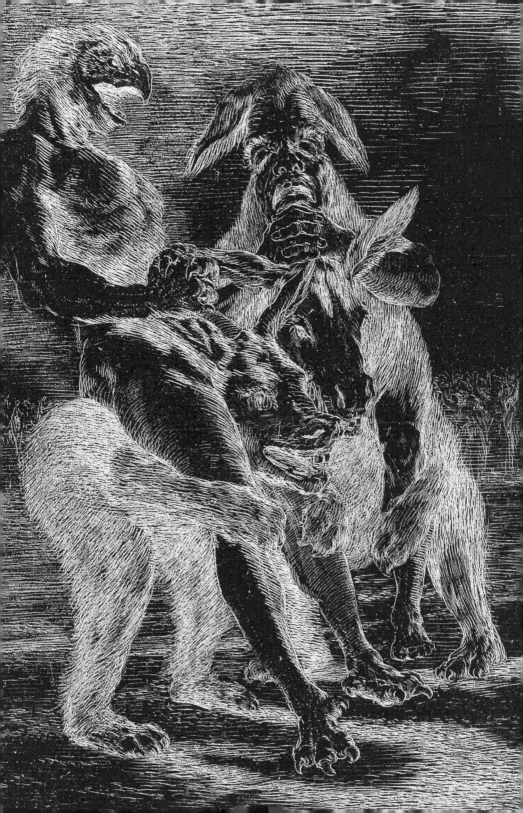

concealed behind a mask that is as white as the moon, with big sorrowful eyes, tears running down the smooth cheeks and thick pouting lips. The man is wearing high-heeled shoes, and a flesh-coloured knitted suit under a shiny bikini. His artificial breasts bulge like ripe melons. His arms are stretched out as if in supplication and he holds what appears to be a white egg in each hand. There is no caption to explain what is happening, just the name of the village and the date on which the photograph was taken. It must have been carnival time and the cold weather would account for the need of a knitted suit.

A man whose face is hidden behind a plate-shaped mask is walking along a sandy track. His eyes are painted white circles, his teeth are long wooden spikes, two feathers stick up from the top of his head like rabbits' ears. He holds what might be a rifle in his hand, or is it a whip? Three thin dogs are slinking by his side in the early morning mist. The devil out hunting.

A young woman with her breasts bared dances down a street, while men clap their hands and laugh. A young man dances with a gourd held like a huge penis between his legs and the dangling testicles are made from castanets. The women clap their hands and laugh.

I remember again the Easter festivals in the towns and villages near to where Goya was born. A man grinning as he examined the sticky blood on the palms of his hands. A man carrying a wooden crucifix, smoking a cigarette and flirting with a woman who was wearing a veil of black lace and carrying a banner on which a bleeding heart had been painted. The stuff of dreams and fantasies, made as real and as tangible as ordinary daily life.

18

Family of
Charles IV

I have been reading about the Bourbon kings. They had long, lugubrious noses, heavy chins, bulky bodies and surprisingly small hands. They had the habit of inter-marriage which made many members of the family mad or simple-minded, ugly or slightly deformed. You can see that quite clearly in the big family portrait that Goya made in 1800, in which thirteen of them are gathered together.

The old king, Charles III, filled the apartments of the Alcazar Palace in Madrid with musical clocks and exotic birds in cages of gilded wire. You can imagine the air thick and nervous with the whirring melodies of the clocks and the burbling cries of the birds. A scarlet macaw imitates the chiming of little bells. A rufous-browed peppershrike repeats a monotonous sequence of notes that will only stop when darkness falls. A painted bunting makes the sound of tinkling water. A myna bird cries out sharply like a member of the palace guard.

The soft-fleshed gods and goddesses are busy with one another on the high ceilings. The furniture glistens. The solemn faces of royalty gaze out from walls hung with cloth of gold and silver. The Elysian fields of the carpets and

the shimmering inlaid surfaces of the polished marble floors are scattered with the husks of seeds and little drifting feathers. Servants patter about on soft shoes, winding up the delicately ticking mechanisms of the clocks. They move from birdcage to birdcage, changing food and water and checking that the pretty prisoners are still alive and healthy. Sometimes they must remove the limp body of one whose colours have faded and whose round eyes have gone blank and opaque.

So much for the past. In the present I went to the palace quite late in the afternoon and walked in a hurry through the ornate and echoing rooms, swept along with other tourists. I had forgotten to bring a pencil, but a guard lent me one and watched as I made notes in the room in which two violoncellos, two violins and a viola, all made by Stradivarius, were held in glass cases like a collection of stuffed birds, beautifully preserved and as mute as if they were carved from stone.

These instruments had belonged to Charles IV. He used to enjoy playing the violin, he even played something for Goya, in the days when the Court Painter was still able to listen. But the King was so unskilled at his music that when he played to an audience, a second violinist would be stationed behind a curtain, to accompany him and carry him over the difficult bits.

What else do I know about this King? He still believed that the English owned the American colonies, twenty years after the War of Independence. Like his father, he collected timepieces, but watches rather than clocks, and he had a servant to wear the ones he was not wearing himself because they always worked better if they were kept warm.

The King's brother, Don Antonio Pasque, was an epileptic and an imbecile; you can see him looming over the royal shoulder in that group portrait, like the reflection from a distorting mirror. The King's sister, Dona Maria Josefa, was described as being 'not very tall, but a little deformed and having an ugly face'. She is there too, only a few weeks before her death, with a huge beauty spot floating on the surface of one cheek like a ragged island.

Above all things, the King loved to go hunting: summer and winter, morning and afternoon, every day of the year when he was not interrupted by state ceremonies, by the need to sit for a portrait, or, eventually, by the invasion of Napoleon's troops and the outbreak of the chaos of the Peninsular War. Two hundred and fifty persons usually accompanied him on an ordinary hunt, but on special occasions as many as two thousand soldiers were lined up with their guns, to decimate the game as it attempted to escape.

In the gardens of Charles IV's palace of Aranjuez, high scaffolds were erected for servants to stand on and count the number of birds killed by their king. A big green net was draped over the fruit gardens, not so much to keep the birds off as to hold them in a canopied trap for when the King felt like shooting finches. If he had nothing better to do he would launch an attack on the rooks, crows and vultures that fed on the pile of old carcasses left there especially for that purpose. Once he sent home a cartload of horns to be used as decoration for the palace and people made jokes about his wife and her many infidelities, but he took no notice of what people said.

He liked to travel as fast as possible in his coach. Three of his guards were killed and four more were seriously

wounded as they did their best to hurtle along the track just ahead of him.

Every year he moved from one palace to the next according to tradition and the seasons and whatever ceremonies needed to be attended to. A vast retinue of courtiers and hangers-on moved with him. In 1802, when a double wedding for his son and his daughter was held in the city of Zaragoza, it was estimated that some eighty thousand people accompanied the King and the Queen from Madrid. They spread out across the land like a rehearsal for the invading armies of the French and the English who would soon be coming. They slept in the woods and burnt down the trees, using the hollow trunk of an ancient and famous cork oak as a fireplace and almost setting the entire forest alight in the process. They stripped the fields of crops and killed the domestic animals they came across as well as the wild ones. Anyone who claimed to be connected with the royal entourage had the right to appropriate other people's horses, mules, donkeys and oxen as well as their hospitality. Coaches were stopped on the road and their occupants were ordered to get out and were left stranded with their luggage.

Whenever the King passed a bridge, a crossroads or some other landmark that caught his eye, the place was marked with the royal sign, declaring that His Majesty had gone this way. When he stayed as the impromptu guest in the house of one of his subjects, he might leave behind a special chain that could be hung above the door, indicating the honour that had been bestowed.

The King made jokes. He turned on the hosepipes in the water gardens at San Ildefonso and sprayed everyone who had gathered there to watch him. He had inherited

his huge physical bulk from his mother's side of the family
and used to enjoy hitting or punching people in a friendly
way, but with such force that it caused them to buckle up
with pain. That made him laugh until the tears came to
his eyes. He was fond of a test of strength in which you
try to force your opponent's fingers backwards, but when
an opponent played him and won, the King hit the man
in the face.

Every year he was obliged by ancestral custom to spend
sixty-three days in the grim monastic building of the
Escorial. But there was good hunting to be done in the
park, where great herds of deer and wild boar lived undis-
turbed among the cork and beech trees. He tried to make
the palace more light-hearted by filling the upstairs apart-
ments with tapestries, bright paintings and the gaudy
decorations of which he and his wife were so fond. But he
still could not avoid the weekly visit to his dead forebears;
down the steps of granite and polished marble and into
that cold octagonal space called the Pantheon, where the
walls were lined with royal tombs like larvae in a beehive.
The first of the black and gold caskets held Philip II and
then there were the rest of the Spanish Hapsburg line,
followed by their close relations, the Bourbons. The King's
own casket was already in place, named and waiting to
receive him.

His favourite palace was Aranjuez, just south of Madrid,
and he was always busy arranging for more ground to be
levelled, more banks to be smoothed, more pagodas and
railings to be erected. He had what he called a Labourer's
Cottage built in the garden. It was a decorative brick pavil-
ion, with walls lined in panels of silver and floors laid out
in patterns of mosaic. He would cook meals for himself in

the kitchen of his cottage and then go to visit the work-shops of the royal carpenters and armourers, turning the wood for them and giving the finishing touches to the metal. In that way he could see himself as a simple man, proud of the deftness of his little hands.

Charles had married his cousin, Maria Luisa of Parma, when he was sixteen and she was only fourteen. She bore him twenty-two children of whom six survived. The youngest was rumoured to be sired by her favourite, Manuel Godoy, sometimes known as the Sausage Maker (because the area he came from was famous for its sausages and because of rude jokes as well). Godoy began his career as a royal bodyguard and once he had found favour with the Queen she heaped him with gifts, honours and decor-ations. He also became established as the King's trusted friend and right-hand man, responsible for telling him how things were going in the country and the world around. He was made Commander-in-Chief of the army, and Universal Minister, and the title Prince of Peace was bestowed upon him. His servants wore red stockings – a privilege previ-ously reserved for members of the royal household. In the portrait Goya made of him he exudes the smug sleekness of a well-fed, neutered tomcat.

Because of her infidelities, the Queen was known as the Whore, and because she had the misfortune to lose all her teeth she was also referred to as the Toothless Whore. She had three attendants whose job was to manage the well-being of her false teeth, to adjust the plates and to make them as comfortable as possible.

There was a lot of very savage gossip about Maria Luisa. The Russian Ambassador said she had the 'hectic mask of a ravaged courtesan', and Napoleon described the shock

of meeting her when she and her husband were on their way to exile in France. She was by then in her early fifties with yellow and red flowers tucked in her grey hair and wearing an orange crêpe dress she had managed to borrow from the Empress Josephine. 'She has her past and her character written on her face,' said Napoleon, 'and it surpasses anything one dares imagine.'

It might be possible to presume that many of the stories told about Maria Luisa were based on political malice, were it not for her own letters to Godoy. She wishes that the Duchess of Alba would be thrown into a pit. She describes a daughter-in-law as 'this slut who fans the flame . . . a diabolical serpent, the phlegm that crackles in the fire', while her son Ferdinand is a 'spiked vine of cowardice'. In an image that could have been illustrated by Goya, she says she wants to 'take them both in hand and cut their wings'.

In the year 1799 Goya was in high favour at Court. 'The Kings are crazy about your friend,' he said to Zapater. In September he made the portrait of the Queen in the traditional black lace outfit of a *maja*, which was in fashion at that time, and of the King in hunting dress. In October he was appointed as First Painter to the Court, with a salary of fifty thousand reales a year and the promise of a new house. In that same month he painted portraits of the King and Queen on horseback. He never seemed to enjoy painting horses and these two are heavy amphibious creatures that might have been ridden by the god Poseidon. The Queen was delighted with the image of herself. 'It is an even better likeness than the one in the mantilla,' she said to Godoy.

Then, in the spring of 1800, Goya was asked to 'do us

all together' and so he began the preparatory work for that painting called *The Family of Charles IV*, in which a dynastic nest of thirteen Bourbons are gathered in a stuffy-looking room. The light from a high window pours down on them from one side, to illuminate the nakedness of their faces, the intricacy of their costumes and decorations and the watery darkness of the shadows they cast and stand in.

The work was done at the Aranjuez Palace and Goya made four journeys there by carriage, carrying his canvases, stretchers and painting materials. During May and June he completed ten studies from life of the principal members of the family, doing their heads and shoulders against a red ochre background that has the colour of dried blood. All the sitters declared themselves delighted with the result, even the King's brother and sister who both look as grotesque as they do mad.

Goya captures his subjects one by one, and when he knows them well enough he is ready to crowd them all together like a flock of perplexed sheep, huddled into a corner of the Ariadne Room, waiting to be told what to do next. No conversation is possible; just the request to move a little closer, to hold still, to turn the face slightly towards the slow river of daylight that falls from the window.

The Queen dominates the stage. She is adorned like a church relic with a diamond Cupid's arrow shot into her hair. Her mouth hangs slightly open, as if she was listening with it, as a snake does. The King is stiff, red-faced and solemn; a glittering constellation of medals shines on his chest. Ferdinand, the sixteen-year-old Prince of Asturias, seems burdened by the unnatural size of his head and the smallness of his body; it is tempting to say that his anger and resentment are already becoming visible.

Then there is the princess who will soon die and the princess whose body is partially crippled and all the others with their backs to the wall as they wait for the painter to execute his craft. In the palpable darkness that lies around them, you can see Goya, a silent witness who makes no comment, but gives a shape to everything he sees.

19

Goya continued to receive a salary as First Painter to the Court, but he made no further portraits of the King and Queen. They were far too busy with the muddled confusion of family intrigues and resentments. No time to sit for a portrait that would only show how they were growing older and more ugly. No time to notice that war was creeping closer, step by step, a predatory animal with a smile on its face watching a country and its people, preparing to pounce, to bite, to tear things limb from limb.

Goya kept silent within his own silence. His life was going well. In 1802 he moved to a new house on the Street of the Green Valley which was on the corner of the Street of Disenchantment. He had plenty of money: jewellery to lock in a safe, paintings by Correggio and Tiepolo, prints by Rembrandt, a copy of a painting by Velasquez. He had forty-one upholstered chairs and a sofa covered in yellow satin. There was food and drink in the cupboards. Javier, his son, had survived childhood and was becoming a man. Josefa, his wife, had survived childbirth and was becoming an old woman. He was approaching his sixtieth year. He wore his stovepipe hat. He drank sweet chocolate milk, flavoured with cinnamon.

This was the year in which the Duchess of Alba died and everyone presumed she had been poisoned. Goya had the painting of her dressed in black hanging on the wall. Looking at the youth and defiance in her face, his thoughts flew silently inside his head like birds.

He painted people: face after face staring out into the world. He made portraits of his friends and of new clients who were prepared to pay him more than ever before. There were those who complained he painted too fast and was not always concerned with the end result. He charged extra for hands. He had no objection to wiping one face off the canvas and replacing it with another, adapting the details of a costume accordingly.

In 1804 there was a sense of gathering doom, although no one as yet knew what form that doom might finally take. They said the sky rained blood. Rivers burst their banks and whole villages were swept away. Yellow fever was killing people in Andalusia in the south and the plague was spreading along the coast from Barcelona to Cadiz. The price of wheat had almost doubled and the poor were on the move, trying to escape the threat of starvation which galloped after them like the phantom carrying a scythe. The country roads had always been dangerous, but now they became almost impassable because of the bands of robbers who took possession of different stretches of territory. The cities were full to overflowing with homeless beggars, competing with each other in the display of hunger, deformity and despair.

In 1805 Goya's son Javier was married to Gumersinda Goicoechea, the daughter of a rich merchant. A pretty seventeen-year-old girl called Leocadia Zorilla was related to the bride's family and must have been at the wedding, but

her story does not become relevant until several years later.
Goya provided the new young couple with a fine house on
the Street of Kings, right in the centre of the city. He made
a portrait of Javier, stepping forward with a long stride, as
lean and fashionable as any dandy, with a small lapdog dan-
cing at his heels. And one of his daughter-in-law with an
even smaller dog. And then a miniature of Josefa done in
profile as part of a series of miniatures which included the
parents of the bride and her sisters. They all share the same
round, comfortable, well-fed faces, and the same curiously
bland stare, as if their heads were empty of everything apart
from thoughts about what money can buy and a vague
mistrust of the human race.

At this same time Goya was also keeping a vivid record
of what was happening in the city. He went out into the
streets and he used his eyes. He no longer needed to
draw the monsters of his imagination because the streets
were filled with monsters. Cripples struggling to drag
themselves forward; fat men burdened by the obscenity
of their greed; desolate women not knowing how they
would be able to protect their children when things got
even worse. People running, falling, fighting, screaming;
the whole heap of struggling humanity trying to keep
afloat.

I am sure he could see more clearly what was happen-
ing and what was about to happen because he was not
disturbed by the usual babble of talk. He was free to read
the anger and the fear, free to walk through the streets and
smell the approach of a storm.

As well as the street scenes he made two wonderful
etchings: one of a tree bent by the wind, with a high arched
bridge in the background; the other of a huge boulder set

in front of a waterfall. But he destroyed both these plates later, cutting them up and using the backs of them for part of the series that became known as *The Disasters of War*.

I have been trying to think about war, but I have no experience of war. I have been trying to imagine seeing heaps of people lying dead in a landscape of pale hills and stony fields or among the broken ruins of their houses, but I have no experience of such death.

I was born in 1948. As a child I used to ask my parents what they had seen and done during the last war. My father was a conscientious objector. For a few months he stoked coal in the boiler room of a merchant vessel that was travelling around the Orkney Islands. He showed me the copy of Proust he was reading at the time, the pages covered with black smudges. He remembered coming out on deck when the ship was going past an island in the sunset and how beautiful it was. Later he was in the Fire Service during the Blitz. He told me that after a bombing raid he picked up a metal helmet that was still warm from the heat of the blast and there were fragments of a man's skull inside it. This was his only recollection of violence.

During that same time my mother was working as a secretary in a branch of the Admiralty. She went to numerous parties and for the rest of her life she preserved her favourite party dress in a plastic bag smelling of mothballs.

It was a glistening tube of black velvet, topped by a band of white fox fur. When she died I did not know what to do with it and so I threw it away, the fur a faded nicotine-yellow but the velvet still strangely alive.

She kept a diary for each year of the war. They are tiny books in which there is just enough space for a dentist appointment in the afternoon and a supper in the evening. Between 1939 and 1945 she made no mention of bombs dropping, friends taking their leave, the movement of armies or the deportation of peoples, but she drew a little star against every night that she made love, the pages spangled with stars. Her paintings during this period were of crowded forests with no room for a path between the thin trunks of the trees and human faces divided into segments like oranges, the mouths open and the eyes wide with fear.

age 61

Goya's war came to the Iberian Peninsula in 1807 and stayed there until 1812. As I understand it, it was really a war between England and France that happened to be fought on Spanish and Portuguese soil. It was a war of random slaughter and terrible confusion in which as many soldiers were killed by hunger, disease and exhaustion as by gunshot and the sword. It was a war in which the women in the towns and villages could expect to be raped by their English allies as well as by their French enemies and anyway they found it hard to tell the difference between the two invading armies of foreigners, although they noticed that the English cavalry cut the tails of their horses much shorter than the French.

As the mindless attrition of the years moved on, every-

one began to have a reason to want to take revenge on everyone else; savagery was answered by even more savagery and the land was littered with grotesquely mutilated corpses. One man kept a bag full of the ears and the fingers of the soldiers he had ambushed and killed. A mule driver was hung from an open window as a punishment for stealing an apple, the offending fruit rammed into his mouth. In the neglected fields and the desolate countryside, the arms and legs of the dead could be seen bursting out of their shallow graves as if they were a crop that had been planted as seeds in the autumn and was now sprouting into life. A town and all its inhabitants was burnt to the ground by the soldiers who had come to liberate it. Two thousand horses were shot and thrown into the sea at La Coruña, just so that no one else could ever ride them.

When I read about the Peninsular War I find myself floundering among accounts of military strategy, dynastic ambition and all sorts of unnecessary betrayals. Right at the beginning the royal families of both Portugal and Spain manage to escape to a safe place and then new rulers come and go, battles are won and lost and it hardly seems to matter which side you are on since there is no way of disentangling right from wrong, the just from the unjust; there is only cruelty answered by more cruelty.

A while ago I made a study of Napoleon at the end of his life when he was a prisoner on the island of Saint Helena. I watched him pacing through his windswept garden, lying for hours in the bath and fervently dictating page after page of memoirs as he tried to work out where his plans had gone wrong. He seemed to see history as a simple equation, with himself on one side and a mass of

soldiers, women and children, kings, queens and generals, cities and roads, snowstorms and famine on the other. He decided in retrospect that the invasion of Spain had been a mistake.

But what did Goya think of it all? Goya crouching like a toad, or was he more of a dragon by now, with his dragon's hoard of fine jewels and upholstered chairs, his newly acquired houses, his royal salary and his well-paid portrait commissions? What did he think of what he saw in the city and in the countryside and in the faces of the living and the dead?

He remained in Madrid for most of the war. It is possible, but not certain, that he witnessed the first precipitation of violence on 2 May 1808 when riots broke out between angry demonstrators who were armed with sticks and stones and pitchforks and foot soldiers and men on horseback who were armed with rifles and swords.

On the following day all the people suspected of being in some way involved in this riot were herded together in groups. Some were lined up to be shot in the streets, others were taken to be shot in the fields of Moncloa on the outskirts of the city.

Even if he was not there for the actual killings, Goya must have seen the evidence of what had happened: the smeared blood of men and horses, the marks made by bullets biting into stone, torn fragments of clothing,

discarded shoes, broken windows, women weeping, children staring, men turning their backs. Much later, when the war had ended, he painted two famous works to commemorate the events of those two days that had marked its beginning.

In August 1808 he went to Zaragoza. The city had been besieged by enemy forces for three months and, against all the odds, the enemy had been driven back. Now there was a temporary respite during which everyone was busy preparing for a second and more violent siege. The thick city walls were being fortified with earth and sandbags. There were barricades erected across the streets. The living had stored the necessities of life in the relative safety of underground cellars while the dead were being hastily buried. Cartridges were manufactured in the monasteries and convents and women and children were busy washing bucketloads of soil from which they could collect saltpetre to be made into gunpowder. Paving stones, roof tiles and broken glass were already piled into heaps, ready to hurl at the enemy.

During the first siege the French attackers had lost three thousand five hundred men, while the Spanish defenders lost perhaps twice that number. Many of the dead were the women and children who were fighting in the doorways and front rooms of their own homes.

The second siege began in November and produced a total of almost seventy thousand corpses. Once the outer walls of the city had been broken, the houses were destroyed block by block and their ruins formed the advanced position for the next wave of bombardment. The lunatics from the city asylum were set free so that they could join in the fight. Many of the people trapped in

cellars and underground passageways were killed by fever, dysentery and typhus and when they were defeated and forced to emerge from their hiding places it was like seeing the dead rise on a terrible Day of Judgement.

Goya was invited to visit Zaragoza by the defending general, José de Palafox, who wanted him to paint his portrait. He went there on his own, travelling through a familiar landscape towards this place of his childhood. He smelt the sweet stink of putrefaction where the dead were left to rot in the fierce heat of the summer sun, and the sharp stink of burnt houses and flesh. He saw the silence of broken furniture scattered on the road as if it had been carried and dumped by the winds of a hurricane. He saw overturned carts harnessed to the bloated bodies of oxen, their legs thin and stiff in the air. The vultures were well fed and wolves and scavenging dogs were busy in the trampled fields.

When he arrived in Zaragoza an army of new recruits was being trained for the next battle. People were half-mad with the fervour of anticipated bloodshed and the desperation of their situation. An angry mob turned on a man who was suspected of cowardice or treachery and they beat him to death in the street. A child was seen kicking the corpse of a dead soldier as if it could be forced to feel more pain.

Goya made drawings and the first preparatory sketches for the portrait of General Palafox. He took his leave of the city before the November siege and went to stay for a few weeks with his brother who was living in that farmhouse on the edge of Fuendetodos. The travelling carnival of war did not pay any attention to a little village called 'The Fountain that Belongs to Everybody' and it must

have seemed as if there was no war and never had been.

In February or March he made his way back to Madrid. Almost half a million hungry soldiers were now moving like swarms of insects across the landscape. It was a very cold winter and the mountain roads that led from one battlefield to the next were littered with the bodies of the dead and the dying, the snow stained with their blood.

The people in the little towns and villages who had no faith in this war, and who saw themselves being killed without mercy or reason, were beginning to take their own form of revenge. They hunted the enemy with the same cunning and perseverance they used in hunting wild boar or the wolves which attacked their flocks. If they had no rifles, then they had pitchforks and knives. They castrated the soldiers who had raped their women and once they had stripped a human carcass of its covering of clothes they punished it further by hacking off the limbs. Mutilated bodies were hung among the branches of trees, as a warning to others. And then the men who had killed were punished in their turn, making it hard for a stranger to tell the nationality of one dead body from another. Some of the foreign soldiers had their wives and even a child or two with them, but the people who lived here had their whole families to lose and that made them more fierce and compensated for their lack of weapons.

Back in his studio in the house on the Street of the Green Valley, Goya produced a series of little paintings of murder, rape, shootings, prisoners, fire. The victims of each fresh attack shine with a luminosity which seems to emanate from the fragility of their bodies. He also made formal portraits of anyone who was prepared to pay his fee. He could no longer collect his royal salary now that the

royal family was in exile. He sold some of his jewellery to
pay for the necessities of life.

Two years after his journey to Zaragoza he began work
on the series of etchings known as *The Disasters of War*.
Materials were hard to come by and so he used any copper
plates he could find, even if they were of poor quality or
disparate sizes. He took the plates on which he had etched
two landscapes resonant with tranquillity and he cut them
in half. On the reverse sides he scratched and burnt and
dug into the surface of the shining metal until he had made
four images: a woman being raped by soldiers; a man being
dragged backwards up a ladder towards a gallow's noose;
a man blindfolded and tied to a post; and a terrible tangle
of dead women caught in the act of tumbling through the
ruins of a broken house, in which only a single, elegant,
carved chair remains intact, everything else being shattered
and beyond all hope of recovery.

22

Goya, in the silence and solitude of his studio on the Street of the Green Valley, looked at his country. He painted soldiers, tiny in the landscape that surrounded them, and he painted what he saw looming above them: the vast, muscular, naked torso of a giant, as indifferent as a ghost, his fist raised for a new fight, his head turned away and his legs dissolving like smoke in the blueness of the sky.

He moved closer and made a drawing of a grotesque, swollen animal lying like a hill on its side, gorged with the bodies of dead men that are crammed into its open mouth.

This was a war that went on long enough for soldiers to fight in fields where the ground was already covered with human bones from an earlier battle. For them to try to dig pits to bury their dead, only to find the earth already full of corpses.

The soldiers raped the women and girls they found hiding in the houses and then killed them afterwards to wipe out the memory of what had been done. They stole gold and silver from the churches and then ate the bullocks that pulled the carts that carried the treasure, leaving glittering

crucifixes, golden caskets and paintings cut from their frames scattered like rubbish on the ground.

Everyone was hungry and the hunger increased as the land became increasingly neglected. The soldiers tried to grind the heads of sheaves of wheat into an edible paste. They smashed mahogany tables, fine carriages and chairs to make fires on which they could roast a few potatoes. They shot domestic cattle and pigs when they were lucky and ate cats and rats and dogs when there was nothing else. After the Battle of Talavera a fire sprang up among the long dried grasses where the dead and the dying lay and men were ashamed because their pangs of hunger increased with the smell of roasting meat.

They drank water from muddy pools and leeches festooned the inside of their mouths. They drank water from wells in which corpses had been thrown. They were sick with brain fevers and dysentery and malnutrition and anything else that came their way and their wounds festered with maggots during the heat of the summer and became black and gangrenous during the cold of the winter. A soldier described approaching a convent that was being used as a hospital: a heap of amputated limbs lay along the outside wall while more arms and legs kept flying out of the windows where the doctors were still at work.

In between the fighting the Duke of Wellington found time to go fox-hunting in the hills north of Madrid, using a pack of hounds he had brought from England for that purpose. He went hunting for wolves in the mountains around Talavera and one of his officers took pity on three orphaned wolf cubs which he cared for until they had become as docile and playful as kittens. Another officer had a pet baboon.

The women and children who accompanied the army struggled to keep up with their menfolk on the long marches across the high mountain passes and through land that had already been laid waste by those who had gone before. They stood to one side during the chaos and noise of the battle and then, once it was over, moved forward to examine the bodies of the dead and the wounded, searching for a familiar face.

When the regiments of two opposing armies were camped close together by a tributary of the River Tagus, they had swimming and jumping competitions. They exchanged tobacco for brandy and sat up talking through the night, the fires from the burning villages illuminating the sky. There were many lizards in that area and black snakes.

A victorious regiment went through the streets of a ruined town where the troops of the defeated army were sick and starving and they handed out supplies of biscuits from their own meagre army rations. A wounded man was nursed back to health by the men who had wounded him: they kept him for fifty days and then let him go. Deserters were made to dig the trenches into which their bodies would fall when they were shot. The triumphant soldiers who came to liberate the town of San Sebastian towards the end of the war became so drunk and savage with their victory that, following a night of killing and rape, they burnt the town to the ground.

Goya remained in Madrid. After the eruption of violence on 2 and 3 May there was not much bloodshed here, just the shifting of power from one hand to another, the sense of bated breath as people wondered fearfully what would happen next and the distant but relentless hubbub of

slaughter and atrocity that was blowing this way and that across the land like a pestilential wind.

Food became increasingly scarce in the city until there was an entire year of famine, the 'hunger year' as it was called. It lasted from September 1811 to August 1812 and caused the death of some twenty thousand people.

Walking through the streets, Goya saw the sound of people's desperation. He saw men, women and children lying in silent heaps like fish caught in a net, their eyes wide open and startled by the arrival of death. He saw the heavy, noisy carts that came rumbling on metal wheels over the cobblestones twice a day to collect the fresh victims of hunger, tumbling them all together, young and old, male and female. A young woman was heaved into the cart by her feet, her body so relaxed and beautiful it was as if she was asleep and dreaming of sexual pleasure.

Walking through the streets, Goya saw all the madness and hysteria that suffering brings in its wake. A crippled dwarf being carried on a stretcher so that women and children could kiss his deformity for good luck. Men who were whipping their naked backs into a froth of blood in order to appease a savage and speechless god. Two women fighting over the possession of a chicken's head which could be cooked to provide a whole family with the illusion of nourishment. Young girls whose breasts had not yet ripened and prim careful housewives offering their bodies for sale to anyone who could give them a little bag of millet or a loaf of stale bread in return.

He saw the shivering hallucinations of hunger. People swayed as they walked as if they were on a ship at sea. Some bodies were grey and puffy and hollow-looking, others had lost all flesh so that the workings of the skeleton was revealed.

Goya made drawings of what he saw in the streets and in the dark shelter of archways and cellars. He turned his drawings into the next eighteen etchings for *The Disasters of War*.

23

During that same time when sudden and unnecessary death was spreading everywhere across the country and the rustle and scratch of famine was beginning to creep through the streets of Madrid, Goya made a series of still lifes. There were known to be twelve of them in total, although only ten have survived. They were all painted on the same sized canvas and it is thought that they were probably hung on the walls of the dining room in the house on the Street of the Green Valley.

One of these still lifes is a traditional composition of a bowl of fruit, a row of bottles, a wooden cask, three loaves of bread, and five slices of salami. The others are nothing like that. They are intimate portraits of dead birds, animals and fish that have, each in their own way, been killed by an act of violence. Those that still have eyes stare with a disbelieving gaze at a world they can no longer see. The body of a salmon has been cut into three chunks of anonymous flesh. Part of the head of a sheep is propped against two sections of its own carcass. A turkey has been stripped of its feathers to reveal the nakedness and vulnerability of its pink skin. All the other creatures are not visibly damaged, but are made limp and helpless by the fact of their own death.

Goya paints what he sees. In *The Disasters of War* the dead are piled like a crop of turnips in a field, their dismembered body parts are hung like fruit from the trees, they are left to rot in abandoned houses. You have to look at what he shows you and yet you cannot look without looking away, ashamed of what you have seen.

In the still lifes Goya confronts mortality without the burden of horror or the confusion of shame. You pick up a wounded bird. It weighs almost nothing in your hands. You marvel at the layered beauty of the feathers, the perfection of the waxy beak, the delicate miracle of the feet. And then, as you watch, the bright eyes grow dim and you bear witness to that amphibious moment when the flicker of life is extinguished like the flame of a candle. You see how the body changes once the life inside it has gone. You feel you have learnt something about the fact of dying.

In *Still Life with Golden Bream*, six little fishes lie heaped up on each other. They are so recently dead that they are still gleaming with life and their round staring eyes are without the glaze of absence that will come in the next moment. The darkness of the night is illuminated by the moon that catches on the breaking foam at the edge of the sea behind them. The moon also shines on their wet and glistening bodies that are as golden as the sun.

Then the intimacy of the *Still Life with Woodcocks*; again there seems to be six of them, although it is hard to disentangle one from the next. Their feathers are soft enough for you to feel them brushing against your lips. Two of them lean their heads together and look as though they are engaged in a dance of courtship.

A plucked turkey suspended by its feet is as limp and vulnerable as that woman who was being lifted into the

famine cart. And another turkey, dressed as finely as any king in its coat of glossy black and white feathers seems to be asleep, with legs extended, eyes closed, and the wings lifted and outstretched in a dream of flight.

For these works Goya painted with his fingers and with a palette knife as well as using brushes. Some areas of the canvas are tinted with a gloss of colour that is as thin and transparent as varnish, others are covered with a thick paste of paint. Into the deep pool of grey and white light on which the body of the feathered turkey is resting, he has written the four letters of his name with the tip of his finger. Into the dark sand where the little fish are lying, he has written his name in the same way. His signature is also to be found in a tiny blood-red script under the mutilated head of the sheep. You can almost hear him grunting and sighing to himself as he works.

age 66

Goya in his house remained deaf. In 1812 his wife Josefa died after thirty-nine years of marriage. There is only the one drawing that is known to represent her, which shows her in profile so she does not meet her husband's gaze. She wears a ribboned cap and a pale shawl is pulled around her heavy sloping shoulders as if to conceal the outline of the body underneath. She appears to be closed in upon herself.

When she was dead an inventory was made of the contents of the house on the Street of the Green Valley. According to the instructions of the will which had been drawn up by the couple the year before, Goya and his son were to take an equal share of the assets. As a result of this division Javier inherited some money and jewellery, some furniture, silver and linen and he also became the owner of the house itself, his father's library of over two hundred books and the complete collection of his father's paintings and drawings. He marked each picture with a cross and a number.

Goya for his part was left with the use of his own house, for which he agreed to pay a small rent. Most of the furniture, linen and silver was undisturbed and he had a great deal of money and jewellery.

He remained where he was. He made drawings of what he saw happening in the world around him and he wrote comments under the drawings as a way of talking to himself and anyone else who wanted to hear what an old deaf man had to say: 'Be quiet, time changes the hours' under the image of a woman sitting desolate by a tombstone. 'Less savage than some' for a wild black man dressed in skins and feathers. 'What horror for the sake of revenge' for a man tied by his feet to a tree, his face contorted with the shock of what is being done to him.

Goya continued his work on the etchings for *The Disasters of War*, moving from the famine of 1812 to the events which took place after the famine when the madness of the savagery of the war was followed by the madness of the savagery of King Ferdinand who took control of the country once the war was over. The people themselves had also gone mad from too much suffering and from the taste of blood which kept driving them into a frenzy of more killings. 'Death to Liberty!' they cried when they welcomed the King into their city. And in response to their welcome he closed the universities, opened a new school of bull-fighting, brought back the power and authority of the Inquisition and began the first of many purges against anyone who might be an enemy. People could be arrested for wearing 'liberal clothes', for owning a recently published book, for being denounced by their neighbour for one thing or another. The King's henchmen broke into houses at night to make their arrests. Some were sent to prison without trial while others were tortured and garrotted in public places. Many of those who knew they were in danger went into hiding and later escaped as exiles.

Goya was an old man. He heard nothing, he kept quiet

and he was left alone. He made paintings for himself which he hung on the walls of his house: an Inquisition trial; a procession of flagellants; the massed crowd at a bullfight; the massed crowd at a carnival; a lunatic asylum in which one of the naked inmates wears the horns of a bull, another wears a tricorne hat and shoots an invisible rifle at an invisible enemy and a third, wearing a crown of playing cards, holds a sceptre and sings to himself with his eyes tight shut.

Goya produced commissioned work when it was asked of him. In an equestrian portrait he rubbed out the face of the deposed Bonaparte King Joseph and replaced it with the face of the Duke of Wellington, recently victorious. He made another and more intimate portrait of Wellington during that same time in 1812: the long equine face staring blankly outwards as if seeing a ghost. Maybe he was seeing the corpses from so many battles heaped up fresh in his mind, the sound of their dying loud in his ears.

The Duke was so pleased with this portrait that he insisted on taking it with him on his final and most terrible campaigns in the north of the country. The canvas was not yet quite dry and it was forced into a frame that was too small. It was returned to Goya a couple of years later so that he could retouch the damaged areas and add the glittering array of extra medals and honours that the Duke had accumulated by the end of the war. Goya did his best; the red cloth of the military uniform bristles with swirls and lumps of new paint. In a private notebook he drew a little caricature of the Duke as a strutting peacock of vanity.

In 1808 he had had the brief opportunity to make a pencil sketch of Prince Ferdinand who later became

Spain's new king. The drooping weight of the chin and the narrow split of the mouth give the face the look of a ventriloquist's dummy; the widely spaced eyes are blank and malevolent. Goya must have referred to this drawing later when various cities commissioned a royal portrait as proof of their loyalty and obedience, but the unpleasantness of the face was camouflaged by the presence of fine costumes, swirling curtains, a sword in the King's hand and a sleeping lion at the King's feet.

Goya in his house remained deaf. People writing about him say that by now he must have been a disllusioned man, horrified by what he had seen and tormented by the phantoms of his own imagination. But perhaps not. After all, he had the power to turn every thought, every fear, every painful confrontation with the reality of daily life, into images that sang and danced and triumphed over the limitations of human existence. He protected himself from the danger of madness by daring to look into its eyes. He saw how men, women and children were being humiliated, tortured and killed, and by showing what he saw he gave them a voice, even after they were dead.

And anyway he must have by now started an affair with Leocadia. She was forty-two years his junior and the two of them often quarrelled, but she was with him until his death.

Goya silent in a silent house. At night he could feel the
uneasy heartbeat of the city in the muffled darkness. The
echoing crackle of movement in his own joints and liga-
ments was like the sound of the approach of danger. The
hiss and rush of blood coursing through his body was like
the sound of whispered fear. Doors were being broken
open and doors were being slammed shut, people were
made to disappear but the streets were empty of witnesses
and even the nightwatchmen who called the passing of the
hours were nowhere to be seen.

One day in 1815 Goya was summoned to appear before
a tribunal so that he could be questioned about which side
he had been on during the war and which side he was on
now. But since he could not hear the questions, how could
he be expected to give an answer? A few trusted acquain-
tances agreed to testify on his behalf. They explained his
deafness and isolation. They also swore to his patriotism
and his allegiance to King Ferdinand. He escaped punish-
ment and for the time being he was left alone. He had to
be careful; many of his friends were less lucky.

In the following year he was told he must appear before
the court of the Inquisition. They wanted to question his

motives for doing a painting in 1800 in which a nude woman lies so shamelessly on white pillows and a white sheet. And to ask about the *Caprichos* etchings and what they might mean.

There is no record of this trial having ever taken place and so presumably it was indefinitely postponed. The deaf man was not pushed through the streets of the city in a cart, his hands bound together, a tall pointed cap on his head and his crimes written on the yellow cape that covered him. He was not made to sit in the Inquisition chamber, where a judge could pronounce your guilt even before you opened your mouth to speak and where a sea of indifferent faces were quick to decide what punishment was most appropriate.

Goya made a series of drawings of the victims of such purges. One man is condemned for having been born in a foreign country, another is found guilty because he is a cripple and has no legs. A woman is chained by the neck against a wall, because she is a liberal. When Goya writes comments underneath his drawings, it is as if he is passing through the barrier of prison guards and prison walls, and sitting beside the prisoners talking to them. He tells a woman it is better if she does not open her eyes to see what is happening. He tries to comfort a man who is weeping.

In 1815 he made a portrait of himself. He must have sat at the easel and leant out sideways so that he could stare at the reflected image that confronted him in a mirror. He is sixty-nine years old. His curly hair is grey around the temples, but it becomes black within the swirling darkness that surrounds him. His white shirt is open to reveal the vulnerability and unexpected softness of his ageing

skin, the weight of the flesh around the jaw, the thickening of the neck. The expression of the face is tired and serious but curiously detached; it is as if the man who is being painted is preoccupied with his own thoughts and quite unaware of the fact of being observed so closely.

He was also making paintings of young and beautiful women who seemed not to realise they were being looked at. Two of them sit side by side on a balcony, while the dangerous shadows of two men can just be distinguished behind them. One leans forward against a balcony rail, as enticing as a ripe fruit, and ignoring the presence of the old woman crouching beside her, as ominous as the figure of Death itself. Two women stand together in the sunlight. One of them is reading a letter and people say she has Leocadia's perfect oval face. She is very young, her skin is firm and smooth, the solid flesh of her body is clearly visible under the black cloth of her dress.

Leocadia was the youngest daughter of wealthy parents of Basque origin, but her father died when she was four years old and her mother when she was six. She was brought up by guardians and probably spent much of her childhood in a convent. In 1807, at the age of nineteen, she married Isidoro Weiss, the son of a Bavarian jeweller. According to the complicated clauses of the marriage settlement, she and her husband agreed to live in the house of her father-in-law and her large dowry was incorporated into the family business. A first child, a boy, was born in 1808 and a second son, Guillermo, in February 1811. However, the marriage was already in serious difficulties and in October of that same year Isidoro claimed power of attorney over his wife, accusing her of 'unlawful dealings' and later of 'infidelity, illicit relations and bad behaviour'. He

also claimed that she had a 'high-handed and threatening disposition'.

In 1814 she gave birth to a girl, Rosario, who was registered as 'the daughter of Don Isidoro Weiss and Leocadia Zorilla, his lawful wife of the same address', but it is likely that by then the two of them were living apart. It is also likely that Goya was the child's father, and that the 'unlawful dealings' and infidelity referred to the start of the affair between the old man and the young woman. That would explain why Goya's wife wanted to make a joint will just before her death, safeguarding the future of her only son at the expense of her husband. It would also explain the root of Javier's hatred of Leocadia which persisted so fiercely throughout the time that she shared his father's life and even after his father's death.

I went to a bullfight in Zaragoza. Goya had been to the bullring many times when he was living in the city and in his mind he often returned to watch the fights he had seen here, as they unfolded themselves step by step in his memory.

He sees the matador arching his back and rising on his toes as he prepares to lunge forward with the sword. He sees the muscles rippling in the bull's shoulders as it twists its heavy body towards the fluttering enticement of the cape. The massed energy of the crowd has congealed into a many-tentacled creature that roars and sighs with a single voice. The shadow of the man and the shadow of the bull have merged together to make a third presence that dances in the sand and fights for its life.

I watched as the muttering pool of faces began to fill up the rows of narrow-tiered seats. I could smell the human smell of cigar smoke, sweat and perfume and the animal smell of horses and bulls. A perfect circle of clear blue sky was hanging above the bowl of the amphitheatre and the perfect circle of yellow sand had been raked as smooth as a beach at low tide.

I imagined wandering through the labyrinth of narrow

corridors that lead into the ring and entering one of the little cubicles in which each bull is kept in darkness before being driven out into the dazzle of sunlight. For a moment my fingers could feel the marks made by the tips of horns battering into the heavy wood of the closed doors.

It was Easter Sunday and almost everyone gathered here was in their best clothes, full of talk and laughter. I searched among the mass of spectators for someone whom Goya might have noticed or someone who could be mistaken for him.

A few seats to my left and sitting very much on her own, there was a woman dressed in the costume of a *maja*: a black lace shawl pulled around her small shoulders, red ribbons plaited into her black hair, gold hoop earrings, white powder, red lipstick. She was no longer young and her face was tired under its mask of make-up, but still she was beautiful and defiant in the knowledge of the power of her beauty. She stared fixedly ahead and hardly seemed to notice her surroundings; she could have been watching the rain falling on the other side of a closed window.

Immediately on my right and so close I could breathe the sweet taste of wine on his breath, there was a man blinking through hooded eyelids, like an owl. He was also traditionally dressed in a black suit and a white shirt and he also appeared to be oblivious of where he was. He kept looking at the woman, but although she must have been aware of his gaze, she never acknowledged it. I thought perhaps they had once been lovers and I invented stories of what had happened between them.

And then a blind man carrying a white stick was herded carefully forward among a group of friends. They went to sit in the front row and he settled himself in readiness for

the fight, his arms resting on the wooden balustrade, sniffing the air like a dog as he followed the babble of sounds all around him. I decided that I could put Goya next to him; the blind and the deaf side by side.

Suddenly there was a fanfare of music from the orchestra and the sun glinted on the metal of trumpets and cymbals as the men who were going to do battle with the bulls made their entrance. The seven matadors were all dressed in sombre clothes, six of them in black and the seventh, who looked like nothing more than a child, in a dove-grey suit that clung to his slim body as tightly and softly as a layer of skin.

The music stopped and the ring was again empty. I saw the blind man listening to the silence while the deaf man watched the mounting tension of anticipation. Then the first bull appeared, bursting into view like a flock of startled birds, its hooves skittering on the sand as it raced around the circumference of this new prison.

From the total of seven bulls waiting to be killed on that afternoon, two were black, one brown, two dapple grey and one was a gentle honey colour with even paler rings around the dark pools of its eyes. It was like watching a miracle in reverse, seeing each one of these sparkling vivid creatures being transformed into something as lifeless as the broken branch of a tree. It never took long to move from life to death, perhaps twelve minutes at the most, and when it was over the team of mules with bells jingling in their harness came to drag the corpse away and the sand was again raked clean.

One of the matadors was fifty-six years old and he kept dipping terribly close to the bucking head of the bull as if he was testing his own destiny. Then he was briefly thrown

to the ground and as the crowd held its breath he lay there limp and helpless, the animal lowering above him and time refusing to move forward. He got back on his feet and continued with the fight, a streak of bright blood across his white hair.

The boy was the last to enter the ring. He was sixteen years old but looked much younger, his suit grey and his skin petal-fragile. He reminded me of my own son and that made my fears for his safety much more urgent. He worked with a black bull, the two of them sweeping and turning in perfect unison. Even the killing was part of the choreography of a dance, the bull leaning the full weight of its body on to the tip of the sword held by the boy; the bull kneeling down before him, as if dying was a final act of obeisance.

In that moment the crowd of men and women and children roared together in a single voice of exultation. And in that moment Goya could hear them. The sound vibrated along the wooden bench on which he was sitting. It seeped into the bones of his buttocks, it rose up through his spine, tickling him like the stirring of sexual desire, and it burst into his head, making him roar with the rest of them.

Goya at the bullfight, absorbing what he sees: the old matador lying on the sand as if he was asleep and the bull breathing on his neck; the pale boy and the black bull dancing together; the shifting configurations of shadows on the sand.

He looks up at the tiered rows of faces, rippling and swaying together. He sees that this crowd has the same questing, hungry energy as a crowd of pilgrims approaching a shrine, as soldiers going to battle, as men gathered together to witness an execution. He sees the fickleness

of the crowd, calling for blood and revenge in one moment and begging for mercy and salvation in the next.

Between the years 1815 and 1816, when the war was over but the savagery inherent in a war was still evident throughout the country; when the universities were closed to students but the bullrings were again open for the people, Goya made fifty red crayon drawings on the art of bull-fighting and from these he developed a series of thirty-three etchings. He illustrated the early history of the art of bull-fighting when men had pitted their ingenuity against the strength of wild bulls in the fields and showed how first the Moors and then Spanish kings and emperors had learnt to fight bulls from horseback. He illustrated the stages and passes of the modern bullfight and showed the exploits of a number of famous matadors, many of whom he had seen himself. And somehow in the quiet visual language of his work, he was also able to explain his own view of humanity.

Here is the ring at Zaragoza and the matador Martincho sitting on a chair, his ankles manacled together and his sword pointing at the bull that charges towards him. Here, in the same ring, the horseman Mariano Ceballos looks like a galloping centaur as he confronts his bull, putting spear against horns. Here is Ligereza in Madrid, vaulting over the bull's head and their two bodies merging into one wild shadow.

In 1801 the matador Pepe Illo was gored to death in Madrid. The bull caught him unawares at the start of the fight and lifted him up on its horns, tearing through his stomach and exposing sixteen ribs. Goya made three etchings to commemorate this tragedy. In two of them, which he rejected, the matador is shown in the act of being gored

by the bull. In the third, which was included in the series, he has already been fatally wounded and lies on the sand as voluptuously as a sleeping woman while the bull nuzzles at his side as if seeking to comfort him.

In the fight that I saw in Zaragoza one of the bulls leapt over the barrier around the ring, but there was another and higher barrier separating it from the watching crowd. In a fight that Goya witnessed a bull also broke through the barrier and caused havoc among the spectators. People are shown rushing this way and that in the panic of escape. Some have already been wounded and the body of one man is draped over the bull's head. The creature stands there, huge and merciless under an empty sky, turned now into a terrible hybrid monster, half-human being and half-animal.

In 1819, when he was seventy-three years old, Goya bought himself a country house on a hill and moved there with Leocadia and her two youngest children. Officially she was his housekeeper and that protected them from too much malicious gossip, but those who knew them together later referred to her as his wife.

The house was situated a little to the west of Madrid and just on the other side of the wide sweep of the Manzanares River, where the washerwomen came in their hundreds to rub the dirt from the clothes and sheets of the city and stretch them out in long fluttering lines like the tents and flags of an army encampment. Men came here too, to watch the women as they worked with their sleeves rolled and their skirts up above their knees.

The house was known as the House of the Deaf Man, not because of Goya's condition, but because the previous owner had also been deaf. I like to think he chose it for its name.

It was a very simple summer residence, built from adobe bricks which tended to become damp and crumbly in the wet weather. It stood on about twenty acres of good red earth, some of it laid out as informal gardens and vegetable

plots. A little stream flowed through it to join the Manzanares and five white poplars grew alongside the stream. There was drinking water from a well on the patio and perhaps there was also a fountain, but it is hard to be sure; all traces of the house disappeared long ago, swallowed by the spread of the city. An idea of what it might have been like can only be pieced together from the description in a sales contract and from a few passing comments made by people who saw it during the brief time when Goya was there or later, after he had gone. There is a sketch of the building made by a Frenchman in the 1860s and a photograph was taken in 1901, but that shows a much more sophisticated construction.

From the house Goya had a detached view of the city that had held him for so long: the light from the setting sun catching on the glass in the windows of the rich, making it look as though whole buildings were being consumed by flames.

Over to the left he could see the pale domed roof of the church of San Antonio de la Florida, where twenty years ago he and an assistant had spent four arduous months decorating the arched ceilings with softly coloured frescoes. In the central cupola he had illustrated the story of how Saint Anthony brought a murdered man back to life so that he could reveal the name of his murderer. He placed the scene in a mountain landscape and the rough crowd of men and women gathered to watch the miracle look as though they have come to see a fairground attraction. They hardly notice the saint or the pallid corpse who is whispering a few words to him. The smiling angels in the vaults around the cupola are all so beautiful and sensual in their butterfly robes of red and green and blue that they look like the dancers from a seraglio.

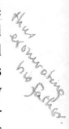

Next to the church Goya could see the tops of the trees surrounding the royal hunting lodge. The deer and partridge were undisturbed by the war and the famine and only recently Goya had been prevented by the royal guards from going hunting in their peaceable kingdom. Not that it mattered any more, now that he could hunt on his own land and fish from his own stream. He could also paint whatever he chose to paint, free from the watchful eyes of King Ferdinand's men who might again want to accuse him of immorality or some other crime, and from the watchful eyes of his son and daughter-in-law who seemed to value his paintings only in terms of what they might be worth and who bitterly resented the recent changes to his way of life.

Beside the hunting lodge there loomed the solid marzipan bulk of the Royal Palace. Looking at it Goya could remember his first trepidation at being led like a prisoner into the enclosed courtyard, past the royal apothecary, through rooms dazzled by mirrors, rooms thick with portraits, rooms glistening with blue tiles, under ceilings heavy with the weight of well-fed gods and goddesses and the fat clouds that served them as beds and chairs.

He could remember the honour of kissing the hand of an ugly red-faced man who punched him in the ribs and cracked jokes he could not hear. Now that man was in exile in France, stripped of all his power and close to death but still keen to go hunting whenever the opportunity arose.

He could remember bowing low before the soft-bodied, pallid-faced Queen, her stomach grotesquely distended by the physical demands of at least twenty-one pregnancies and the falseness of her teeth immediately apparent. She wore a diamond tiara designed to look as though Cupid

had shot one of his arrows among the greying hairs on her head and Goya had made a portrait of her wearing it. He also made an etching of someone very like her: an old crone admiring her withered reflection with that same distinctive tiara perched on her head.

He could remember the effort of always having to agree with each royal request and needing to produce so much work: dozens of designs of light-hearted subjects that were to be turned into tapestries to decorate the vast walls of one palace or another; images of happy country people busy with their happy country pastimes and their simple pleasures. It is true that he sometimes included an edge of danger: in the angry despair of the three peasants in the snow, in the malice lurking in the smile of a young child or in the grotesque pig's face of a man about to marry his pretty bride. But maybe no one noticed.

Goya sat in front of his house built of mud and admired the view. To his right he could see the steep slope of the meadow of San Isidore, where there was a shrine dedicated to the city's patron saint. Every year on 15 May, the people of Madrid made a pilgrimage here, to drink the healing water from the fountain and pray to the image of a holy man who was said to be able to help those in need.

In 1788 Goya had completed a tapestry design of the meadow on the saint's day. It was to have been hung in the bedchamber of the two royal princesses, the one with the humped back and crooked face and the sickly one who died when she was still young. The tapestry was never woven, but the painting was kept rolled up in the palace and it survived the passing of time and the upheavals of politics. It shows a huge crowd of men and women, settled like a chattering flock of birds in the curved bowl of the

hillside. They are feasting and laughing and dancing and flirting, while the sky above them is a luminous eternity of pink and blue and the distant outline of the city appears like a vision of paradise.

Such a world could not survive the war, or the bitter hysteria that had followed yelping at its heels. Nevertheless the saint still had his day and so I imagine Goya working in his garden and watching as a crowd of men and women made their pilgrimage to the holy shrine. Their frivolity had all gone. They walked painfully up the steep slope, muttering their troubles and their fears. They begged the saint to give them some guidance in this present uncertainty and when the saint remained silent then some of them might continue to the crest of the hill, where it was rumoured that witches gathered at night and Satan stood before them in the shape of a monstrous he-goat. Perhaps the powers of darkness could help, when the powers of light had failed.

The people must have all been so desperately tired. After the war there had been the famine and after the famine came the onslaught of yellow fever, also known as the black vomit. It had moved inland from the southern ports and had got as far as Madrid.

The sickness has two stages. First there is severe vomiting and the skin changes colour because the liver is affected. Then there is a lull followed by a fever which can push the temperature as high as 108°F. Until the discovery of the part played by mosquitoes in standing water and the use of quinine, there was no treatment apart from bleeding and purging, cold water and ice and prayers to keep the demons at bay.

Goya became ill towards the end of 1819. He witnessed

the horror of his own body as it emptied itself of foul
liquids, as it changed colour, as it stank. He lay in bed and
stared at the rough surfaces of the adobe walls, while
images floated across the cracks in the mud and erupted
among the flowering patterns of the damp. Perhaps he saw
his own creation, the monster of war, a fat animal gorged
with the bodies of the dead men spilling from its mouth.
Or the rat with bulging eyes, swallowing a creature as big
as himself. Perhaps he saw men tied in sacks, people
perched like birds on the winter branches of a tree, a giant
leering down at him from the ceiling as huge and terrify-
ing as the papier-mâché giants who paraded the streets on
saints' days.

Once again Goya was made to enter the familiar subter-
ranean territory of delirium. Leocadia sat beside his bed
and watched over him. The child Rosario appeared like a
ghost at the door. Doctor Eugenio Arrieta arrived every
day, dressed in a green jacket, his long serious face touched
by an almost maternal tenderness. They all did what they
could and waited.

Goya is caught up in the jostling crowd of his own night-
mares. He sees men and women whose mouths are wide
with screaming. Their leader is a blind man who sings and
plays the guitar, his head lolling on one side. Another crowd
has reached the top of the hill. The black silhouette of Satan
the He-Goat is on the left and the whites of everyone's eyes
slide into view as they stare at him. Goya pulls away from
the horror and sees a woman sitting quietly in a chair on the
right-hand side of the image. He recognises Leocadia. She
is watching over him and protecting him from harm.

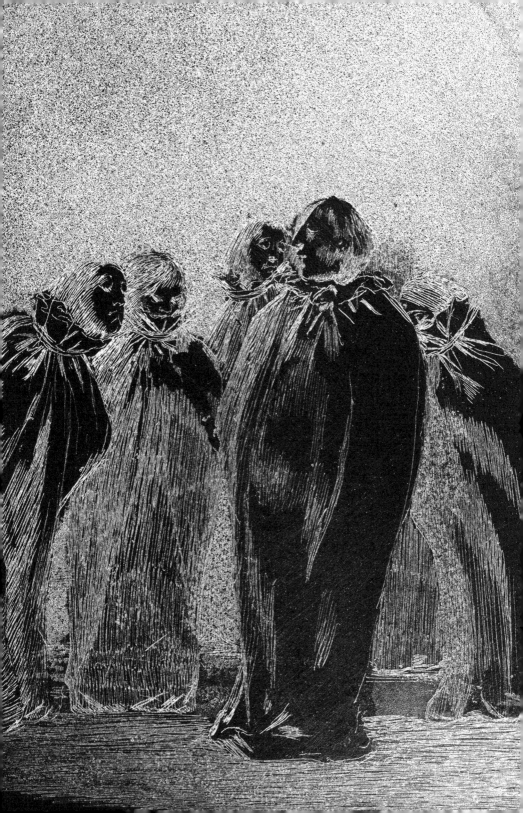

The child Rosario has slipped into the room and she stands beside the bed looking at this man whose face is yellow and bristled with grey stubble, whose mouth is gaping, whose eyelids flicker with a succession of dreams.

For a moment he wakes and catches sight of her. 'I am burning,' he says, 'bring me ice: *hielo, hielo, hielo.*'

But it is too late in the year for ice. The ice houses are all empty until the snow comes again. So Rosario goes to the well and lets the bucket down to the full length of the rope, bringing up the coldest water it holds. She dips her hands into the water, feeling it biting at her skin and bone.

When she returns to the room Goya is still calling for ice, ice, ice, but his words have become the lost cry of a bird and he is back in the closed world of his fever. He sees the ice houses that stand like stone beehives on the empty land around the village where he was born. He follows the white stone path that is scattered with sheep's droppings and alive with jumping crickets. As he approaches the ice house a hoopoe flies so close that the tip of its wing brushes against his cheek. The crest of feathers on its head opens and closes like a woman's fan.

He pushes open the low wooden door. He stands as a child on the threshold and he can smell the ice that is stored there, lying far beneath him in this deep well of stone. Sleeping lumps of ice cut from last year's snow and wrapped safe in layers of straw.

He follows the spiral of stone steps that lead down inside the curved wall. There is no railing and so he must steady himself with the palm of his hand pressed against the stone. The smell of wet straw and frozen water grows stronger as he makes his slow descent. It enters his nostrils like sharp needles.

When he reaches the last step he falls face down on to the mushy floor. He can feel the cold belly of the ice quenching his burning skin. He turns his head to look up at the white square of the open door, as distant as the moon, and then he tumbles into a changed sleep.

When Goya woke in the bedroom of the House of the Deaf Man, the fever had passed. Leocadia was still sitting beside him, her face worn and sad as if she was already mourning his death. Rosario took his hand and moved the loose skin with her small fingers. She turned the hand over, palm upwards, and put a scrap of paper into it. She had used his charcoal to make a drawing of a bird with a long beak.

The doctor arrived, wearing that same green jacket. He saw at once that his patient was going to live. He helped to raise him into a sitting position and gave him a glass of brown liquid to drink. A lizard raced from a corner of the ceiling down to the open window, its pale throat pulsating.

28

I have been staying in a house in Italy, in the foothills of high mountains. At night my dreams are fed by the sound of the river muttering in the valley, by the sudden cry of owls, by the weight of the moon pressing against the thin curtain in the open window, by the scratching of beetles.

Yesterday evening an owl flew low across the terrace, as soft as a ghost; I could have reached out to touch it if I had known it was coming. This morning I sat and watched a toad standing upright against the exposed roots of an olive tree, its old-man legs stretched to their full length, its old-man fingers splayed against the rough surface of the bark.

Later I was looking at an illustration of a painting from the House of the Deaf Man in which two men are up to their knees in mud or sand, hitting each other with long cudgels. According to the footnote next to the picture, cudgel-fighting was once a sport in Salamanca: the men like blood-splattered cockerels in a ring and nothing can pull them apart until one is dead and the other is victorious. I could hear wood thudding into soft flesh, cracking against bone; I could see blood dripping down the wood, blood on hands and faces, blood soaking into the earth. A

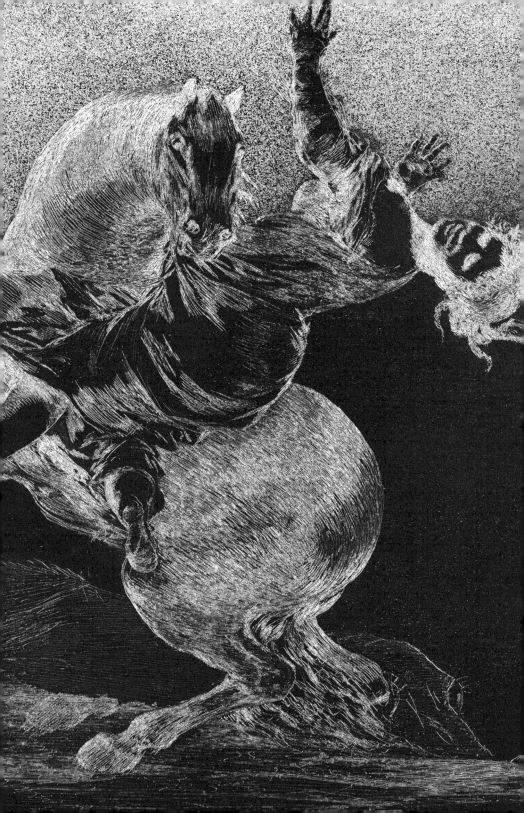

crowd had gathered around, grunting and shuddering with each fresh blow.

I read a chapter from a book about the history of Spain in the nineteenth century. It told me how King Ferdinand's power was taken from him in January 1820 and the liberal Constitution was established. When the King appeared before this new government and swore that he would abide by its rules he wore a blue coat embroidered in gold thread and crimson velvet breeches. His breast glittered with diamonds. The leader of the Constitution party was a man called Rafael del Riego. 'Down with the King! Long live Emperor Riego!' the people cried.

Now everyone was in a turmoil of excitement, discussing what should be done next, and every street corner and café was full of orators declaiming their vision of the future and how it must be shaped. The liberals demanded the death of the priests, while the priests demanded the death of the liberals. Those who lived in the countryside tended to be conservative, and those who lived in the city tended to be progressive, but whenever a crowd gathered it quickly transformed itself into a mob, hungry for revenge and changing allegiance with the direction of the wind. A mad priest who had plotted to bring back the King was dragged out of prison and beaten to death with a hammer. An angry crowd swarmed like ants up the walls of the Royal Palace, screaming at the windows and demanding the surrender of the King so that they could tear him to pieces. People everywhere were dying sudden and violent deaths. It was like a continuation of the war, but now the enemy had made his home within the heart of the country. My history book explained that this was the real beginning of the Civil War which would take more than a hundred years to burn

itself out: the vendetta of murder and betrayal bouncing mercilessly down through the generations. For a moment I was back in the town of Belchite where the ghosts of the dead and the wounded were still so busy, the evidence of bloodshed embedded like fossils in the broken walls of the buildings and the paving stones on the streets.

Goya in the House of the Deaf Man was out of the immediate reach of danger and he could watch the confusion of the times unfolding. In April 1820 he went with other members of the Madrid Academy of Fine Arts of San Fernando to swear his allegiance to the new Constitution. But already by July 1821, that government was in complete disarray and it became obvious that this was going to be only one more chapter in the long narrative of chaos.

Goya, in the House of the Deaf Man, arranged for new drains to be dug, fences to be erected, vines to be planted and living quarters to be built for a gardener. He went fishing in his own stream, hunted for hares on the crest of the hill where the witches were said to gather and looked at the city that glimmered silent in the distance. He went down to the banks of the river to watch the washerwomen who told each other rude jokes he could only follow by the gestures that accompanied them.

He had returned to the childhood recollection of the scent of the earth after rain, the smell of cut grass and crushed walnut leaves, the beauty of the image of a beetle poised on a flower, a long-eared owl flying across the luminous disc of the full moon. At night he slept beside Leocadia, pressing his skin against hers, warming his cold feet between her thighs. The little girl Rosario was six years old in 1822. He called her his Ladybird and was already delighting in her precocious aptitude for drawing and painting.

It was probably around this time that he completed the final plates for that beautiful, mad, wild and wise series of etchings knew as the *Disparates* – a difficult word to translate because it means something between folly and dream. A man rides into the night sky on the back of a creature that is half-horse and half-monstrous bird. A huge empty-faced ghost, wrapped in a shroud, looms above a group of terrified soldiers, a smiling giant plays the castanets, an elderly man, who looks like an old reptile, sits on a chair and ignores the people who mock and gesticulate around him. A horse carries the weight of a big sensual woman by gripping her skirt between its teeth. She swings next to its flank like a baby in a sling and smiles in a private ecstasy of pleasure.

No prints were ever taken from these plates and when Goya had to leave Spain they were wrapped up and put away in a cupboard. No one knew of their existence until long after his death.

Once Goya had recovered from the illness which almost killed him, he set to work with a relentless intensity. He had decided to use the walls of his house as a series of canvases on which to make new paintings. I can see him passing excitedly from room to room, running the palm of his hand across the uneven plastered surfaces as if he was stroking the flanks of huge animals, putting his face close as if he was breathing in their warm life.

The House of the Deaf Man had two main rooms, one above the other and both measuring about thirty feet by fifteen. There was only one or perhaps two windows for each of these rooms in spite of their size, and so they must have always been as dark and cool as a cave, even during the hot summer months.

I imagine Goya enjoying the luxury of one of these large dim spaces; moving slowly this way and that like a fish in a pond. A rectangular pool of light from a window lay floating on the wooden floor and the faint shadows of the leaves of the trees in the garden shook themselves softly within this pool.

The silence here was quite different to the silence he had known in the city. It was not the private isolation of

his own deafness, but something as strong and pervasive as the scent of jasmine flowers in the evening and whoever was in the house shared this silence with him.

He went to the window and looked out on to the patio: the stone well, the plants in pots, the pencil-thin leaves of the mimosa, the waxy leaves of the lemon tree, the flickering silver leaves of a white poplar. He was reassured by the fact that nothing dramatic had been happening just beyond the reach of his eyes. It was not like being in his house in Madrid where he could step on to the narrow shelf of a metal balcony to be confronted by the shock of a human river in full flood in the street below: soldiers displaying the wounds of war; water sellers and orange sellers, beggars, orators and madmen, familiar faces and strange ones, all shouting and crying and making demands. Here the silence was real.

He returned to the walls. He began the necessary preparations. He had done this sort of work before in the church of San Antonio de la Florida and in other churches as well.

He fetched scaffolding planks, ladders and trestles. He draped cloths over the floor and over the larger pieces of furniture. He used a big earthenware bowl to mix up a first batch of fresh plaster according to his own recipe. He applied a layer of this stuff on to one of the walls, using a trowel to spread it in sweeping strokes and then working at it with a stiff brush to produce the thick striation of ridges known as the tooth, because of the way it will bite hold of the paint. The damp smell of the plaster made the room even more like a cave.

He worked on his own although perhaps Leocadia and the little Rosario came to watch him and to help if he asked for their help. The limited light source from the windows

had to serve as the painted light source in the pictures. The inherent darkness in the rooms had to be used as an aspect of the work. He wanted to show what the darkness could contain.

I used to know a painter who covered his canvases with dangerous words: acts of violence, murder and suicide, the name of his ex-wife and other names of people he hated; a terrible inventory of maledictions all huddled up against each other like creatures trapped on the edge of an abyss. Then, once he felt he had said everything he needed to say, he would dip his finger into black oil paint and eradicate the words, letter by letter. The final image was completely abstract and yet it still had a sinister power as if you could feel the secrets it held, clamouring just beneath the surface.

And now here is an odd thought. It would seem from the evidence of recent radiography and statigraphy performed on the paintings from the walls of the House of the Deaf Man that with most of them Goya began by laying out a number of wide, brightly coloured landscapes. He created a sweet-smiling natural world in which the sky was blue, the earth was green and the sun shone down on contented people who were busy with their simple lives. Then, in the reverse procedure of my friend with his strings of maledictions, he began to hide his first creations, obliterating the day and turning it into a thick night, covering the bright colours with shades of black and ochre, spreading fear like a pestilence across each new image.

Underneath the painting known as *The Pilgrimage to San Isidoro*, in which a terrible crowd of men and women blunder through the moon-dark hills following a blind guitar player, there are traces of a wide panorama of mountain

ranges where a great bridge with three arches crosses a river.

Underneath the god Saturn, his body emaciated by age and an insatiable hunger, there is the just discernible outline of a man performing a simple peasant dance, his arms raised above his head and one foot lifted for the next step.

And underneath the solemn portrait known to represent Leocadia, dressed all in black with a black veil shielding her face and leaning against the railings of what looks like a freshly dug grave, there is another Leocadia whose face is not hidden and who has little pompoms on her shoes and rests her arm on the corner of a mantelpiece.

Goya surrounded himself with the companionship of this work. He made a total of fourteen paintings in those two main rooms and then moved on to paint the wooden panels in several smaller rooms and the walls around the staircase that connected the ground floor with the upper floor.

I went to the Prado Museum for the first time a few years ago. I stopped in front of Goya's portrait of the royal family in which they stand like actors after a performance waiting for the applause that will never come. I stopped in front of King Ferdinand with his mad sullen stare and huge flat chin; the little paintings of the madhouse, the Inquisition trial, the flagellants, the bullfight, the self-portrait in which the artist sees old age creeping up on him like a cold wind.

Then I was in the rooms that hold the so-called Black Paintings lifted from the walls of the House of the Deaf Man and fixed on to canvas. I did not yet know that Goya was deaf, but I remember it was the sound of the paintings that struck me first: a great hollow booming reverberation

like a mixture of thunder and human voices. And it seemed to me then as if it was the paintings themselves that were brave; as if they had dared to look into the face of all this and had survived.

30

There was a big storm last night. The trees, still heavy with autumn leaves, were struggling in the noisy darkness. The rain clattered like a cascade of sharp stones. The wind panted around the walls of the house and sucked at the windows and doors. The house closed in upon itself, waiting for the danger to pass.

The storm has been continuing all day and it is too drenching wet to go outside. I keep thinking of Goya in the House of the Deaf Man; contained within it like the beating heart inside a living creature, Jonah inside the whale.

I think of him walking through those painted rooms, surrounded by the dark and flickering images that are spread across the walls from the ceiling to the floor. They all compete for his attention. Some call out to him in savage, urgent voices, others entice him with their silence and their longing. He potters among them, holding a branched candelabra in his hand so that he can observe them more clearly. The little flames of the candelabra illuminate the faces that peer out at him, making their features shift and change with a ghostly animation: an eye blinking shut, a mouth stretching open, a hand about to grasp. He does not

give names to his paintings or words to the stories they tell, but he sometimes talks to them, asks them questions and watches for an answer.

In the big room on the ground floor he pauses in front of the ancient couple hanging above the far door, who eat soup from a single bowl. It is as if he has never seen them before. He wonders why they want to keep themselves alive, when their bodies are as dead as skeletons, their faces as cruel as skulls. He turns back and walks towards the painting of the woman who looks like Leocadia. The contours of her naked body are tangible under the black covering of her dress; even her sadness stirs him with a tremor of desire. He runs his hand over the rough surface of the paint.

In the big room upstairs he goes at once to the dog's head which peers up into an expanse of yellow light. He has always loved dogs, especially little hunting dogs like this one. The shimmering dappled yellow light makes him think of a tree in the sunshine with a thousand restless birds hidden out of sight among its leaves.

He laughs with the two women who are laughing at the masturbating man. The man's mouth is opening slowly and he can hear him groaning as he labours towards his pleasure.

Sometimes he takes his family with him through the rooms of the house. In more peaceful times Leocadia took Rosario to the fair or the circus whenever she could and now, when going anywhere is dangerous, the paintings have become the spectacle of a wider world. They stop and look and think their own thoughts and the two adults smile to reassure the child. They listen to the blind man who plays the violin and to the roar of the crowd who follow in his

wake. They are shocked by the hungry giant who is eating a human being and frightened of the woman who holds a knife. 'Who will win?' Goya asks Rosario in his deaf man's monotone, pointing at the two men who are hitting each other with long clubs. She grins and shrugs her shoulders because she does not know.

The three of them were there in the House of the Deaf Man when the liberal Constitution government collapsed in 1823. King Ferdinand was welcomed back. He made a triumphant entry into Madrid, riding on a chariot that was pulled by twenty-four young men. 'Long Live the Inquisition! Death to the Constitution!' cried the people.

The King rewarded those he felt had been on his side with new titles of nobility. There was now a Marquis of Loyalty as well as a Marquis of Royal Appreciation. He quickly inaugurated a new wave of bloody reprisals to punish everyone suspected of having been against him. The old liberals were referred to as 'the blacks' and there was the wish to destroy whole families of them, down to the fourth generation. Men and women were openly set upon in the streets. The organisation known as The Exterminating Angel introduced the old Inquisition practice of denouncing anyone suspected of having the wrong beliefs and the priests and other members of the church worked together to root out evil. A man seen carrying a yellow handkerchief had the side whiskers and moustaches stripped from his face and he was paraded through the streets with a cowbell tied around his neck, because yellow was known to be a colour of the liberals. A woman could be shaved, tarred and feathered for wearing a yellow ribbon.

The thousands of men and women who were under threat of imprisonment or execution went into hiding or

tried to flee the country. Some managed to escape but others were not so fortunate. A schoolmaster called Cayetano Ripoll was condemned to be hanged for not attending Mass on Sundays and a barrel painted with flames was placed under the gallows as a reminder of the old Inquisition practices. General Riego, who had once been a fêted hero of the people, was captured while trying to escape over the Portuguese border. He was put into a basket and dragged through the streets tied to a donkey's tail. He was publicly disembowelled before he was hanged. A guerrilla leader who had fought bravely against the French during the Peninsular War was meticulously tortured in prison and brought out every market day in a cage of iron, so that he could be mocked before he died.

Goya and his family watched the changes. In August 1823 he drew up a deed of gift, making the house and the grounds over to his seventeen-year-old grandson, Mariano, 'to give proof of the affections which he felt for [him]'. In this document the improvements he has made to the house and the garden are all listed, but there is no mention of the paintings which cover the walls.

In 1823 Leocadia's son Guillermo went into exile in France. Although he was only thirteen years old, he was said to be a member of the Militia who were fighting against Ferdinand and so his life was in danger. Leocadia was also under threat as a result of her own liberal views and on account of her son, so she was obliged to go into hiding, 'to escape persecution and insults of every kind'.

In January 1824 a system of organised repression established 'permanent military commissions with executive powers to judge the enemies of absolute power' and laws of strict censorship were imposed. In that same month

Goya went into hiding in the house of the Aragonese priest Father José Duaso and he put Rosario in the care of the gentle-faced architect Tiburcio.

On 1 May 1824 a brief amnesty was declared and on the following day Goya applied for leave 'to take the mineral waters at Plombières in France, to alleviate the sufferings and infirmities which are such a burden to his old age'. The permission was granted by royal authority on 3 May and on 24 June the Sub-Prefect of Bayonne informed the French Minister of the Interior that 'D. Francisco de Goya, Spanish artist whose papers are enclosed, has this day been granted a provisional pass for Paris, whither he is travelling for medical consultations and for the purpose of taking the waters thereby to be prescribed'.

Goya turned his back on the House of the Deaf Man with no idea of when he might be there again. He knew that the paintings could not withstand the onslaught of the weather for too long; eventually the cold and damp of winter would eat through the mud walls and erupt in broken blisters and swirling patterns of mould across the painted surfaces. But he had not made the pictures to last, not to be sold and passed on from one owner to the next, not to outlive him into some uncertain future. The house and everything it contained was as fragile and mortal as a human being. It was just a question of time. And now he was leaving and going to another country to begin a new life for as long as life was granted to him.

31

I have had one house in my life which I loved more than any other. The place made time stand still for me; as if the uncertain trajectory of my own destiny could somehow be contained and held safe within the walls of a building. I even presumed I would eventually be buried in the garden beside the pear tree and, without any particular sadness, I often stood on the patch of grass under which I could imagine myself lying: stiff and silent and beyond caring.

When I had to leave that house it was as if I was being separated from the shell of my own body and from the accumulation of dreams and memories that had gathered there around me. I remember walking from room to room, watching how the sunlight fell through a pane of glass, looking at the gently breathing surfaces of the walls, staring out of the window from which I could see the pond and the window from which I could see the pear tree. I remember closing the door: the finality of it, but also the strange exhilaration that comes from such a huge change.

At the age of seventy-eight, Goya abandoned the house that had become so much a part of him. He left the earth he had cultivated, the vines he had planted, the hares on

the hill, the scent of leaves and flowers, the view of Madrid shimmering like a mirage on the other side of the Manzanares River and the paintings which clung to the plaster surfaces of the walls as if they were complex lichens that had grown there under the gaze of his eyes.

He had not been away from Spain since a visit to Italy almost sixty years before and he had never been to France. Now he planned to go to Bordeaux where there was already a community of Spanish exiles. The journey of some three hundred and fifty kilometres could be accomplished in less than a week if there were no delays, and once again because there is no account of his particular journey I will describe something of the road he took and what he could have seen on the way.

He probably booked a seat on the Catalane mail coach which was a huge and cumbersome contraption painted bright red and pulled by a team of ten mules, their manes threaded with bells and their bodies shaved so that they looked like giant mice. The carriage's suspension was a cat's cradle of knotted rope and it had room for about a dozen passengers who sat inside on faded pink satin cushions. The drivers carried blunderbusses. They wore pointed hats trimmed with velvet and silk pompoms, sheepskin trousers, embroidered gaiters, lambskin jackets and a red sash tied across their chests. A postillion rode ahead on horseback to look out for trouble. Brigands made brave by the recent war and by their intimate knowledge of the mountains were the main threat. But the mules themselves could be danger-ously temperamental, especially if they met with more mules coming from the opposite direction and they had to pass each other on the narrow road.

So here is old man Goya in the month of June, sitting

on pink satin cushions, turning his back on one life and trundling off towards an unknown world. He watched as the carriage passed through the wide and barren land that still surrounds Madrid: grey boulders breaking out of the yellow earth like the ruins of some ancient civilisation. In the distance he could see the solid bulk of the Escorial and the storks floating in dreamy circles above this vast edifice that was both royal palace and royal tomb.

When they reached the first range of mountains a team of six oxen was harnessed ahead of the mules to haul the coach forward. They stopped at the village of Guadarrama. Too many soldiers had already come this way, escaping or being pursued, and by now, although people were still living there, most of the village was in ruins. That night I'll give Goya a thin soup made of goat's milk, served to him by a woman wearing a thickly pleated skirt of red cloth and a tight black velvet bodice braided with gold thread. The story of the devastation of war could be seen in her eyes.

In the city of Segovia they might have visited the Moorish castle: the walls smeared with angry graffiti and excrement, the mosaics on the floor smashed and almost obliterated. A marble slab had been used for executions and the ground was still scattered with little splinters of bone from human skulls.

In Santa Maria of the Snows, the houses were nothing more than mud huts; they had a single opening for a door and a hole in the roof through which the smoke could try to escape. The weather was cold at this height and the people were dressed in thick brown woollen cloth that made them look as though they had been rolling in the

mud. A line of men stood against a wall as if they were waiting to be shot, but all they were doing was basking like dogs in the pale sunshine.

The town of Olmedo was in ruins, with tufts of long grass pushing up out of the confusion of shattered houses. But I'll have them stopping at an inn at the edge of the town and while they were eating a big woman walked in carrying a basket on her hip. She sat down and out of the basket she produced a little cream-coloured puppy which she suckled at her breast. She was a wet nurse on her way from Santander to Madrid and the puppy would keep her milk flowing until she had found work.

In Valladolid a pole had been erected outside the entrance to the town and a man's head was fixed to the pole and left to suffer the battering of the weather. The women here wore yellow petticoats embroidered with birds and flowers.

The city of Burgos was crammed with beggars wearing cloaks which they pulled back, like the curtains on a stage, to reveal the spectacle of their particular deformity. The little children were also wrapped in cloaks and so were the convicts, who made no attempt to escape but were busy sweeping the rubbish of the streets into heaps. Some of them curled up to sleep on the nests they had created.

The journey continued. Goya dozed on the satin cushions, woke and dozed again, his body jolted and shaken by the cobblestones and the rough surfaces of the mountain roads. They stopped at the village of Cubo where the wine was a purple black colour and tasted more of goats than of grapes. The men wore wolf skin caps and the women had thickly braided tails of hair that hung down to

the small of their backs and looked ready to twitch and curl at any moment.

There were many soldiers in the city of Vitoria, their wounds strange and terrible to see. The local theatre put on a show in which a woman dressed as a butterfly walked a tightrope, a strong man twisted metal bars and a very old couple danced the fandango as if it was the last dance of their lives.

On the next day Goya might have seen an ox being hoisted off the ground in a specially made sling, so that new shoes could be fitted to its feet. They passed mules carrying baskets filled with the horseshoes that were made in this part of the country and taken to all corners of Spain. They passed mules carrying women who were accustomed to travelling in pairs, sitting in baskets slung one on either side of the animal's back.

At an inn in the town of Tolosa I would have Goya eating the same food that I was served there: a bright red soup, followed by an omelette cooked with dried cod and then pieces of ox cheek with little patches of black hair still clinging to the seared flesh. The smiling girl who served me, and who could have served him, had Leocadia's perfect oval face and thin nose. When they left the town in the morning little beggar children raced after Goya's coach on bare feet and hurled posies of wild flowers in through the open window.

They arrived in Irun. They rumbled over the low wooden bridge that was painted ox-blood red and they entered France. A few hours later at Bayonne they changed to a different coach drawn by a team of horses, the thick wheels better suited to the flat and sandy tracks that lay ahead. Goya presented himself and his deafness to the

depot-master at Bayonne and a passport was duly granted to 'D. Francisco de Goya, Spanish artist whose papers are hereby enclosed'.

They went through the town of Saint Jean de Luz where all the wooden houses were also painted blood red, but by now they were in a different world. They were no longer climbing and descending the toppling waves of mountains and hills, but were surrounded by a landscape that was spread out like a vast blanket. Sometimes the road was imprisoned by lines of pine trees, their trunks marked with a flesh-pink gash where they were being tapped for resin. And then the trees stepped back to reveal an expanse of soggy marshland and heavy-winged birds rising like ghosts from out of the mists and miasmas. At one point Goya must have thought he was dreaming when he saw four men walking like giant wading birds on tall stiff legs, driving a flock of scrawny sheep across the marshy land. The men stopped in a cluster together in and he saw that they were wearing wooden stilts; several of them were busy knitting socks as they talked together.

After a further thirty-six hours of travelling the coach reached Bordeaux and Goya's friend, the poet Leandro Fernández de Moratin, was there to meet him. 'Goya has arrived,' he wrote in a letter, 'deaf, old, clumsy and weak, without one word of French, without a servant (and no one needs a servant more than he) and yet he is very pleased with himself and so eager to see the world.'

32

I realise with a strange shock that I have arrived at the
final stage of this story. Goya has only four more years to
go. His eyes are bad, his head hurts, his digestive system
is in a terrible state and he is as deaf as a stone.
Nevertheless, in a letter he sent to Javier, he wonders with
a sort of baffled curiosity if, like his fellow painter Titian,
he might yet live to reach the age of ninety-nine. That is
why he needs to be careful with his money, he says, just
in case.

Within the few years that are still left to him he manages
to visit Paris and to return twice to Madrid in spite of the
enormity of such journeys. In Bordeaux he moves house
at least four times, but never complains about the incon-
venience of yet again packing up his wordly goods. He
obviously enjoys the city, with its rootless population of
sailors and foreign traders, political exiles and unemployed
soldiers, beggars and entertainers and prostitutes. He must
feel at home in the atmosphere of shifting uncertainty. He
quarrels with Leocadia but seems to be as happy with her
as she is with him, and there is no one here to accuse them
of immorality. He treats Rosario as his daughter and is
hugely proud of her skill as a young artist. They roam the

streets together in an endless search for more things to see.

During this same period he produces over a hundred drawings and perhaps many more that have since been lost. He learns to master the new techniques of lithography. He experiments with miniature painting on pieces of ivory. He makes a number of full-size portraits and several still lifes which he does 'between two cigarettes'. As he explains in a letter to a friend in his funny, laconic style, 'You must be grateful to me for these poorly written lines, since I have neither sight nor pulse nor pen nor inkwell, I lack everything but my will power and that I have in excess.'

Sometimes, as now, I am daunted by him. I am daunted by his deafness, his self-containment, his genius and by the world he inhabited which is so far away from me. Then all I can do is to search for things I can hold on to; familiar images that might make me feel more at ease in his company.

I remind myself that I have known him since I first met his *Caprichos* etchings when I was still too young to put thoughts into words. I bring back the memory of the smell of linseed oil and turpentine in my mother's studio, breathing it in until my head spins. I wonder again why her paintings frightened me, whereas his were somehow reassuring, even when they were at their most savage.

I move steadily along this path of recollection until I reach my mother's quiet death and that helps to prepare me for Goya's death, which was also quiet, with friends standing around, watching the process of his departure. I look at his self-portraits, the way his face moves from youth into old age, the way he sees himself differently as the years progress.

As part of the exorcism of the doubts that can so easily

crowd around me, I return in my mind to the places I have visited because of Goya. I look again at the landscape of white stone and yellow earth that surrounds the village where he was born. I hear the drums beating like fear itself in the nearby town of Calanda, and I see the mass of people all dressed in the costumes of the Inquisition. I watch the jostling starlings that are still singing crazily on the rooftops of the Duchess of Alba's farmhouse. I walk through the streets of Madrid, Zaragoza, Cadiz and finally of Bordeaux. I arrive at the door of the house in which Goya died, climb the long spiralling staircase, enter the room, look out of the window. I go to the church where his funeral service was held and to the cemetery where his body was first buried.

Slowly and almost imperceptibly I find myself becoming more calm. And then I am back with the image of an old man. He is a few paces ahead of me, walking along the street that used to be called the Street of the Little Moles, because of the many prostitutes who were to be found there, burrowing in the darkness like moles. He wears his cloth cap and pauses to greet the women who all know him by name.

Goya stayed in Bordeaux for only three days and then he set off at once for Paris, 'to consult the physicians' there. He had a provisional travelling pass granted to him by the Sub-Prefect of Bayonne, as well as the address of the lithographic studio he wanted to visit and a letter of introduction to a Spanish lawyer who might be able to help him if he ever felt he needed help. He gave no indication of when he was planning to return, although Moratin warned that a winter in Paris would be the death of him and so he had better get back before the cold weather set in.

Perhaps he was able to book a seat on one of the two new mail coaches known as the Twin Sisters, which could do the trip in fifty-eight hours, but failing that – and he always disliked making arrangements in advance – the journey in the old coach would take three days.

I was reading a contemporary guide for travellers in France and it explained how, before setting off, all passengers had to wait until their name and seat number were called out. I could suddenly see Goya standing beside his luggage, which consisted of little else but drawing and painting materials; his lower jaw juts forward and the grey curls escape from under his cap. Because he avoided letting

people know that he was deaf they might now think he was slightly mad: listening so intently with his eyes and yet failing to make any response when he was supposed to.

Something seemed to change in him from the moment he crossed the border from Spain to France. Perhaps he lost the last vestiges of fear. He had let go of so much already and now the danger of travelling to unknown destinations, the isolation of his deafness, the vulnerability of his ageing body, all seemed like irrelevant details as he waited impatiently to see what each new day had to offer.

So off he went, trundling across a new landscape and this time all that I'll give him on the way is the ghostly apparition of a team of oxen wrapped in white linen cloth to protect them from the biting flies that were so vicious in the low marshlands.

Then he was in Paris. He made drawings of the sights that appealed to him: the mastiff dogs used to pull handcarts, dressed in harness like miniature horses; a woman being carried in a shoulder seat fixed to a man's back; a beggar who had lost both his legs, propelling himself along the street on a wooden platform attached to four wheels which he turned by hand.

He went to the home of the lawyer González Arnau who found him accommodation in the Hotel Favart, opposite the Italian Opera House and near the Boulevard du Temple, which was bursting with fairground activity by day and by night. A billboard stuck to a wall advertised a trapeze act at the Funambules Theatre. Goya could not read French, but he could see Madame Saqui displaying her acrobatic skills on the high wire and there was a date and a time underneath the precarious balance of her little feet.

Ever since Ferdinand's return to power in 1823 there had been a steady stream of Spanish political exiles and refugees seeking asylum in France. The French tolerated the situation but monitored it carefully and kept detailed reports on anyone who might be liable to cause trouble – over four thousand reports were collected during the first six months of 1824. So in spite of the fact that Goya was still the official Court Painter and all his papers were in order, the Minister of the Interior was immediately informed of his arrival and he in turn sent his instructions to the Prefect of Police in Paris:

> This Spaniard . . . is making his way to Paris and is to visit the spas of the Vosges. It would be interesting to see whether during his stay in Paris D. Francisco de Goya enters into any suspicious relations which his position with the Spanish Court would make even more improper. To this end, you should keep him under a close but discreet surveillance, keeping me informed of the results and forewarning me of his departure from Paris.

The first report on Goya stated that 'This foreigner arrived in Paris on 30 June and found lodgings at number 5, Rue de Marivaux. He never receives guests and the difficulties he has in speaking and understanding the French language keep him mostly in his hotel, which he leaves only to visit monuments and walk in public places. He looks older than his seventy [sic] years and is moreover extremely deaf.' Obviously he was not considered as any kind of threat and nothing more was written about him until the day of his return to Bordeaux.

Goya enjoyed Paris. The hotel was ideally suited to his purposes because it was in such a busy area. From his window he could watch the people milling like flies around the Opera House and in a few minutes he could walk to the Boulevard du Temple where the floating poor of the city went to be entertained. Here was a seller of rolled wafers who cried 'This way for pleasure', a man sandwiched between two boards advertising the Paris to Lyon coach service, coconut sellers and dog shearers and puppet shows and a stall with performing fleas and another displaying the mad elastic faces of the professional grimacers. A panorama by Robert Fulton provided circular views of some of the capital cities of the world, while a diorama in the Boulevard Saint Martin showed an interview between King Ferdinand and the Duke of Angoulême. There was tightrope walking at the Funambules and at the Tivoli Theatre the aeronaut Nargat was launched into space from a cannon and returned to earth mounted on the back of a deer. Goya made drawings of what he saw.

Although he met the lawyer Arnau who resolved to do his best for the 'young traveller', as he jokingly referred to him in a letter, it is not known if Goya ever went to one of Arnau's grand soirées where the elite among the Spanish exiles gathered together. Certainly he had no portrait commissions from any of them. He did make a portrait of his friend the banker Joaquim Ferrer and of his wife Manuela and he presented them with a pencil sketch of himself in profile wearing his cloth cap and a beautiful painting of a country bullfight in which a wounded bull stares quietly at a wounded horse in the moments before the next stage of the slaughter begins. He must have done

the painting in his hotel room and maybe the portraits as well.

He might have gone to the Louvre, which was also very close to where he was staying, but what he thought of what he saw is anyone's guess. He made no mention of the new work by Delacroix, Ingres or Constable that was on show at the Salon Exhibition of 1824, but he did refer to someone he called 'the incomparable Monsieur Martin' a deaf-mute miniaturist whose work has all been lost. It is curious to realise that during this same time Delacroix was making copies of the *Caprichos* and a printing firm was producing an edition of six very poor imitations of the etchings, but no one was aware of the deaf old man who was pottering through the backstreets of the city, busy with beggars and acrobats and the smiles of prostitutes.

Apart from the pleasure he took from watching street life, Goya's main purpose in Paris was to visit 'friend Cardano', whom he had met in Madrid in 1819 and who was now an exile here. José Maria Cardano had previously taught him the basic principles of the art of lithography, but Goya was eager to learn the latest developments in technique. Together they could visit dye merchants, work-shops and suppliers of lithographic material. The possibilities of lithography suited Goya perfectly and as well as producing several prints when he was back in Bordeaux he developed a new drawing style in which he used only the greasy lithographic crayon and black chalk to make images that seem to materialise out of the shimmering energy of smoke.

I like to think that while he was in Paris he happened to meet Don Manuel Godoy, the former Prince of Peace and Universal Minister who joined Queen Maria Luisa and

her husband the King during their years of exile in France. Maria Luisa died in 1819, complaining bitterly about the rain and her own despair and Charles IV followed soon after. Godoy then came to Paris and took an apartment close to the Hotel Favart. He spent his time dictating his memoirs and walking in the Jardin de Tuileries. I would have the two of them meeting by chance and then strolling side by side along the tree-lined boulevards that led to the park. They could sit on a bench in the sunshine, and feed the pigeons; Godoy with the face of a well-fed tomcat, perplexed by the way that destiny had dumped him; Goya with the face of a shrewd old peasant, delighted by the way that destiny had given him this last burst of freedom.

On 1 September 1824, the Minister of the Interior was informed that 'Don Francisco de Goya, a Spanish painter aged seventy-eight, who has been the subject of various communications, has obtained the necessary visa to go to Bordeaux'.

For the first two weeks in Bordeaux he was on his own and then Leocadia and her two children came to join him. They rented a hotel apartment on the Cours de Tourny, close to the small popular theatres in the Allées de Tourny, and to the halls in Quinconces where all kinds of human oddities were on display. On their first evening together he could take Leocadia and Rosario to see the man who swallowed live mice and the Incombustible Arab, recently arrived from Paris, who climbed into a hot oven and emerged from it carrying a roasted chicken.

34

I can't help thinking that Goya had never been so happy as he was now in Bordeaux. He could not speak the French language and so he had no need to explain that he could not hear it either. He had the uncertainty of a six-month visa which might or might not be renewed. The money he had saved and his income as Court Painter was all tied up in investments which gave him the freedom of feeling poor, even though this was far from the case. He had no paintings with him to impress potential clients and no possessions either, except for the few things he had been able to bring on the coach from Madrid. So here he was at the age of seventy-eight, staying in rented hotel accommodation with his thirty-six-year-old mistress and her ten-year-old daughter who was surely his daughter too.

An old man cut loose from his own past. An old man living with a woman who was forty-two years younger than himself: her face as pale and perfect as the moon, her body as ripe as a fruit. The poet Moratin said in a letter that the two of them did not seem to be very harmonious when they were first reunited, but by the next letter they had settled down. They were a very well-matched couple. Leocadia 'at times scolds and at times enjoys herself . . .

[She] does not miss a single circus performance and goes to all the fairs', while Goya is 'celebrated for his restlessness, his angers, his passions; he is full of curiosity . . . taking a lively interest in circus animals, acrobats and monsters'.

People writing about Goya have been very critical of Leocadia. In spite of the fact that she originally came from a wealthy and well-respected family, she is often described as nothing more than a servant or housekeeper, who could not have presumed to share her master's bed. Or the fact of her acrimonious divorce from her husband and Moratin's few brief words about her are used to turn her into a shrew and a bully. But if you listen to the dignified anguish in the letters she wrote after Goya's death or look at the pictures he made of young women with pale moon faces and heavy feminine bodies, their skin soft and glittering with sexual warmth, then you feel that she was the root of his new-found contentment and the reason why he could sail towards death with such a carefree ease.

There was also Rosario, the Ladybird, to make him happy. Goya had given her drawing lessons when they were all still living in the House of the Deaf Man. He cut out figures in paper for her to trace and drew things he thought she might like to copy. Some of these joint efforts have survived and you can see her wavering line struggling to keep up with him, like a child following an adult's footsteps in the snow. Here she completes a figure that he has started and here she fills in a solid mass of shadow without completely understanding how that shadow was formed. I imagine them sitting side by side in one of those rooms where the huge Black Paintings roar and chatter from the walls. They are very impressed by each other's

skills and delighted by the way that these skills can combine to make a single image. Together they produce a clown with his arms akimbo and his mouth painted in a round O of surprise and then very tentatively Rosario attempts to produce that same clown on her own. They do a group of children tugging at a little cart, a fat smiling monk, a man on his deathbed.

People writing about Goya get as cross with Rosario as they do with Leocadia. They mock her lack of technical ability, ignoring the fact that she is only six, seven, eight years old at the time. They hate her for daring to interfere with the master's work, as if she was disrespectful, or was trying to deceive future generations of art historians. Some of her early drawings have even been attributed to Goya, which is surely a measure of her success as an imitator. And when she was only twelve she made a beautiful lithograph of the man she considered as her father; it makes him look more like a shopkeeper than a famous artist and shows the stubbornness of him in the protruding lower jaw gripped as tight as a trap. But I have only seen this picture reproduced once in all the many illustrated books I have looked at.

When Rosario was sent to stay with the architect Tiburcio she took on the task of making copies of all the plates from the *Caprichos* etchings. She worked with charcoal and Indian ink to produce a series of images that are curiously flat and lifeless but are nevertheless very sophisticated. She was so dedicated in her labours that she could produce three or four of these copies in a single day. It must have been a way of missing this old man whom she loved, concentrating her thoughts on him without the confusion of words. A fragile nine-year-old, with pale

INTERNAT

THE ADT

golden curls and delicate features, studying the faces of those men with padlocked ears, the monster holding a pair of scissors, the women plucking chickens who have the faces of men, the witches, the masks, the nightmares of deformity. I think of myself at that same age, studying those pictures and being strangely reassured by them. Later Rosario will present Goya with what she has done, confident of his approval and praise.

In Bordeaux, less than a month after moving into Monsieur Bérard's hotel on the Cours de Tourny, Goya wrote to his friend Ferrer in Paris, full of pride in Rosario's skill and plans for her future:

> This famous little creature wants to learn to paint miniatures, and this is also what I want her to do, for at her age the most important thing in the world is for her to do what she wants . . . I would like to send her to Paris for a while, and I would like you to take care of her as if she were my own daughter; and I can pay you with my work or with money from my accounts. I am sending you a small sample of the things she can do; it has amazed all the teachers in Madrid and I hope it will do the same in Paris.

It was possibly because Rosario wanted to do miniatures that Goya decided he would like to do them as well, but it was also a convenient decision, since he had no studio and miniatures could be done at a table. I once knew a painter who had the use of a huge warehouse where he made canvases that covered the expanse of the walls, stepping back to stare at them in the grey and luminous light that seeped in through the big metal-framed windows.

Then he moved to a tiny attic in Paris and worked sitting on the edge of a narrow bed, making the same images as before but now so small that each one could fit into the palm of his hand. So too with Goya, during those early months.

In the winter of 1824 he bought a number of thin slices of ivory. The smallest were some two inches square, while the biggest, which were more roughly shaped, were closer to three and a half inches. A young man named Antonio de Brugada, who specialised in painting remembered seascapes and who spent as much time as he could in Goya's company, has left a detailed description of the process by which these miniatures were made. Goya began by darkening the slip of ivory with diluted lamp black and then, like an alchemist performing a magical act of transformation, he let fall a drop of water which spread across the surface and opened up the darkness with random patches of light through which the ivory gleamed, as enticing as hidden naked skin.

He examined this bright pool to see the mysteries it held, and then he fished out what he could find; scratching and wiping until he had made a woman with her skirts billowing in the wind; a man eating from a dish of leeks; a man searching a dog's belly for fleas; an old man and a young woman; an almost naked woman leaning against a rock, her body as soft as dough.

I imagine Rosario sitting beside him as he works, listening as he talks in a rumbling monotone to himself and to her and to each exquisite new creation as it hatches out of the pool of darkness. Rosario staring up at the old stubborn face, the eyes hidden behind three pairs of spectacles, the heavy crease running from the nostril to the chin,

and then down at the piece of ivory that spins with life. The two of them grinning because this is like a conjurer's trick at the fair, and when he has finished they plan to go to the fair, to see if they can find the donkey that can walk upright on its hind legs like a man.

Goya said in a letter that he had produced forty such 'exercises'. There would have been more, but he did not have enough ivory and so he sometimes wiped away one image for the sake of the pleasure of producing another. They are all like miniature versions of the Black Paintings; filled with that same savagery and energy, even though each one is so small.

Because he did not trust his skill or his patience as a teacher and because there was apparently no eager answer from Ferrer offering to take the little girl under his wing, Goya sent Rosario to art lessons in Bordeaux. First she studied miniatures under Antoine Lacour, who was the drawing master at the Royal Deaf and Dumb School, and then she went to classes given by his more celebrated brother, Pierre. She was taught lithography and instructed in his 'complete course of drawing from the simplest elements to composition', which included learning something called an 'alphabet of landscape', Goya took her to the classes every day and was seen walking up and down among the rows of easels, muttering his dissatisfaction as he examined the precise and academic work that was being produced.

Maybe Rosario had such a natural facility that she became an imitator rather than a painter in her own right. Or maybe the struggle of life was simply too much for her. After Goya's death she and Leocadia were destitute and she needed to earn a living in any way she could: by painting wallpaper

motifs, taking on commissions for miniature portraits or giving drawing lessons. In 1833 a change in the political climate in Spain made it possible for her to return to Madrid with her mother and brother. There she received several commissions to make copies of Old Masters which she did with such skill that one unscrupulous dealer began to sell her work as originals. The Duchess of San Fernando was said to have been so disconcerted by the quality of her Velazquez imitations that she forbade her to do any more.

In 1842 she was named drawing mistress to the young Queen Isabel, but in the June of the following year she got caught in a street uprising as she was leaving the palace and as a result she suffered from a 'terrible inflammation' which caused her death at the age of twenty-eight.

Very little of Rosario's original work survives. There is a pencil self-portrait from which I took her blonde curls and the fragility of her appearance, and a portrait she made of her mother. It shows a woman with a long thin nose, a pale oval face and an expression of terrible sadness. It was done after Goya's death, when Leocadia had many reasons to be sad.

35

Last night I had a dream in which a group of dwarfs were dancing together in a low-ceilinged room. I could not hear the music that was playing, but I could see it in the rhythm of their bodies. They danced on stiff legs which made them rock from one foot to the other and they held their arms awkwardly out from their sides like the wings of penguins. I think I remember that they were all men, but I cannot be sure; certainly they all had narrow foreheads, widely spaced eyes and solemn, theatrical faces. They were turning and turning in that low room, as if they had always been there and would never leave.

A few days before I had seen the 1930s American film called *Freaks*. It is set in a circus. Most of the actors are real circus performers and include those who were known as 'sideshow oddities'. There is a bearded lady, a hermaphrodite, a group of 'pin-heads' who are herded about like a flock of geese, a woman without arms, a pair of Siamese twins who move together as if they were following the careful choreography of a dance, and a black man whose entire body is nothing more than a torso, bound in a knitted sack. There is a scene in which this man lights a cigarette using only his lips and teeth to perform the

complicated manoeuvre and he does it with such a slow dignity you feel he has delivered a long speech about the strangeness of life and death and the human condition.

I would have Goya sharing my dream of dancing dwarfs and recognising them as his own. I would have him watching the film about the circus. The story is a simple one of love and betrayal and so easy to follow that he can forget he is cut off from the words that are spoken and the music that is played. He can seem to hear the high-pitched serious voice of the midget, the tinkling laughter of the Siamese twins, and everything that the man without arms or legs says, as he stares unblinking into the lens of the camera.

I would have Goya watching the film with such intensity that when it was finished he could easily lift it out of his memory and play it again and again before his closed eyes. He makes drawings of the faces that spoke to him most directly. He takes a piece of black chalk and touches the paper so softly you can see the crisscrossing wire marks of its surface showing through. He uses a sharp-tipped greasy crayon to emphasise line and outline and to bring the image into hectic life with a scattering of serrated edges like sparks of energy. He never corrects what he does. I would have him smiling as he works, always smiling, and writing comments at the foot of the drawings: 'True Love', for the midget sitting like a china doll on the broad lap of the trapeze lady; 'Everlasting Friendship' for the Siamese twins whose bodies are joined together from the armpit to the thigh.

According to the poet Moratin, Goya in Bordeaux 'entertains himself with his sketchbooks, walks, eats and takes siestas'. He also reads the local newspapers avidly, to find

out what has happened or is about to happen and what new entertainments are coming to town.

Bordeaux was full of entertainments. Polito's Grand Menagerie arrived in ten coaches drawn by twenty-six horses and erected a tent in the Place Richelieu big enough to hold two thousand people. Every night at seven o'clock you could see the 'Most beautiful lion ever seen in Europe having his dinner in all his ferocity . . . accompanied by a dog who never leaves his side.' The same show was proud to present the Ethiopian Zebra and the Ferocious Hyena of the Cape of Good Hope.

As well as the travelling menageries there were several local organisers of animal fights. Monsieur Duco's team of Bordeaux mastiffs was set against bulls, bears and even wolves. The performances were held in an improvised ring and on several occasions the dogs escaped and caused havoc.

There were two big annual fairs, one in the early summer and one in the autumn. At the October fair of 1824 Goya made a drawing of 'three dwarfs performing . . . the one in the short trousers is eighteen inches high and of the other two (who are husband and wife) she is twenty-one inches and he is twenty'. He sent the drawing to the Countess of San Fernando in the hope that she might like to buy it and perhaps she did. The picture has since disappeared.

For one such fair the local newspaper announced the arrival of a 'superb collection of live snakes: a boa, a twenty-four-foot-long Anaconda; the eighteen-foot Embroidered Snake; the Terrible Rattle Snake, and several live Crocodiles'. Two weeks later a Living Skeleton was on show, 'the only one of its kind, twenty-eight years old . . . 5 foot 3fi inches high

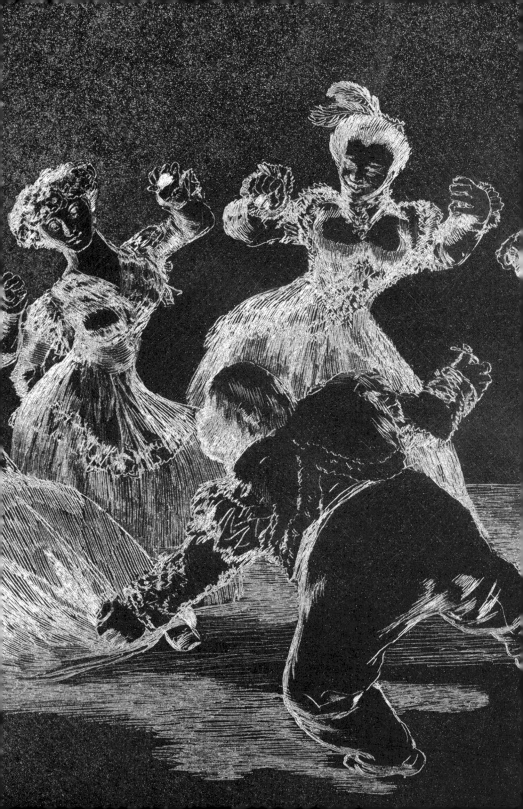

and he weighs only 3 stone 5lbs, his bones being completely without flesh and covered by no more than a thin skin'. This was Claude Ambroise Seurat, on his way back from a successful London tour. He was accompanied by his mother-in-law who carried him in her arms when he needed to go upstairs.

Goya made a drawing of a man in a turban and long flowing robes, balancing a 'crocodile' on his gloved right hand, although the crocodile looks much more like a large lizard. And one of a very elegant black man who holds a boa constrictor draped in muscular curves across his bare head and along the length of his arms. He also drew the Living Skeleton, a look of blank despair on his face and his grotesquely emaciated body quite naked apart from a loincloth.

At the Olympic Circus Goya could see aerial acts such as Satan on Horseback Defeated by the Exterminating Angel, the winged horseman Avillon performing on the high trapeze with Madame Rosalie, or Hercules the tightrope walker, who danced blindfold on a slack rope.

In December 1824, one of the small popular theatres in the Allées de Tourny advertised the 'extraordinary phenomenon' of Yocko the Monkey Man from the Coast of Africa, although they did not explain what it was that made him extraordinary and worth the price of a visit. A few doors further on the famous dog Munito was on view. He could copy texts, solve arithmetical problems, play dominoes and he knew the colours. One of the Bordeaux sketches shows just such a 'literate animal' holding an open book in its huge clawed hands and looking as serious as a judge, as preoccupied as a philosopher. Behind its back a hideous old man armed with a stick watches and grins dangerously.

The petomanes were very popular. These were men who made everyone laugh with their farting skills; they could even play tunes with their anal sphincters. The shows were based on a simple story about eating and vomiting and defecating, and one such 'engastrological sketch' was performed by Monsieur Dufour the Sick Glutton, who might have been the inspiration for Goya's series of drawings of a man eating from a big bowl, a man about to be 'treated' with an enema almost as big as himself and a man sitting on a lavatory.

Goya also illustrated local events he had seen reported in the newspapers, such as the two old men who had a fight over the ownership of a chair, the madman who escaped from the asylum and tried to murder a priest, the rivals who killed each other in a duel in the Allées de Segur after a quarrel about a prostitute, or the peasant, Jean Ramut, who was given a reward of two hundred francs and a silver medal after he fought with a bear, although in Goya's picture the man's bravery is put in question since the bear is no bigger than a dog and lacks any hint of savagery.

The same people who went to the circuses and fairs would go to see the spectacle of a public execution. The newspapers reported the time and the place and an eager crowd would turn up to watch the prisoner being brought to the guillotine on the 'cart of the condemned' and to see how well he or she performed the act of dying. One man was applauded because he showed such earnest repentance, another was mocked when he struggled with the executioner and his assistants. Goya made two drawings of what he called 'French punishment'. In one of them the man who is about to die has his shirt pulled back to expose

his naked shoulders and a stranger's hand is lightly touching the back of his neck as if testing its vulnerability, and the ease with which it will be sliced open.

And then there was the lunatic asylum, the Hospice for the Mentally Ill in the Rue St Jean, surrounded by a wooded area and formal gardens and run by the Sisters of Charity. For a long time the mad had been kept in cages or rooms with barred windows, where, like another circus show, they were regularly exposed to public derision. In 1802 there is a reference to visitors paying two sous to come and see them, and if they proved to be too quiet and docile on that day, then the wardens would beat them to make them more entertaining.

In 1818 the first plans for a new building and a more humane establishment were drawn up, but the work was not completed until 1829. Until then the old building, which was said by now to be in ruins, the walls crumbling, 'the living conditions not unlike a sewer', continued to be used. Visitors were no longer welcomed, but they could obtain special permission to come and view the hundred or more lunatics who were kept there.

Goya made a series of drawings of the madmen of Bordeaux, in which he shows the many faces of mania and alienation. There is the 'happy man', so lost in himself that he is oblivious of his dark captivity; the raving lunatic whose rage is like a chemical reaction transforming his body into a shapeless mass; the man screaming in a delirium; the man bowed down by the weight of his paper helmet; the African trapped in a cage; the emaciated figure who had managed to stick his thin head and one long thin arm out of the cage's bars. A drawing called 'Mad by Mistake', might refer to a case reported in the newspapers in 1825,

in which a man was bringing legal action against the asylum where he had been unjustly detained and treated against his will.

Goya could end a day of entertaining himself with his sketchbooks by visiting the Spanish chocolate house on the Street of the Little Moles. This was where the exiles gathered in a back room to drink thick, sweet, cinnamon-flavoured chocolate, to talk about the homes and families they had lost, to curse King Ferdinand, to talk politics, tell stories, sing, dance and smoke. The shop was owned by a man from Aragon called Braulio Poc. He had fought against Napoleon's invading troups at the Siege of Zaragoza, but with the return of Ferdinand, like so many of his country-men, he had been forced to escape to France. His patrons included intellectual liberals and aristocrats who had supported Napoleon's brother when he ruled in Madrid, but the majority were old soldiers and resistance fighters who had no pay now that the war was over but were afraid to return to Spain. A number of them were wanted by the police and so were known only by their nicknames: the Doctor, the Grandfather, One-Arm, Waistcoat and the Shepherd. Braulio Poc's chocolate manufacturing business was doing well and so he would often feed his hungry clients, providing them with a big pot of meat and vegeta-bles, into which everyone could dip with a wooden spoon. He liked to sing and play the *jota* or other gypsy music on the guitar and then the people forgot their troubles and danced, turning and turning in that low-ceilinged back room, just like figures in a strange dream.

I was in Bordeaux in November. It rained a great deal from a sky that kept growing black and heavy with still more thunderclouds. The elegant eighteenth-century façades of the houses looked as though they had been fashioned out of wet sand and the wildly grinning faces carved above many of the doors and windows glistened with a strange life. At night the tarmac streets took on the appearance of shallow rivers.

I stayed in a hotel on the Rue Huguerie and asked the lady who ran it where I might find the Street of the Little Moles. 'Oh, but this is it,' she said. 'They changed its name.' And blushing with her own outspokenness, she explained shyly who the little moles had been, until the street outside was full of women in dark capes and hoods, beckoning from doorways.

Breakfast was served in a long room without windows at the back of the building. The walls were hung with modern tapestries done in a woollen cross-stitch and murky colours. I sat underneath some huge fleshy foxgloves being assaulted by bees as big as dinner plates. Since I did not know the number of Braulio Poc's chocolate house, I thought that this could well be it and the muffled room

became the place where all the exiles gathered. Goya was hunched in a corner opposite me, glowering at the foxgloves.

I went out into the wet street and he followed. '. . . this Goya will never leave me alone, he follows me everywhere,' said Moratin with a mixture of pride and exasperation.

We entered the Place de Tourny where there had once been so many popular theatres, but now there were none. Goya was almost knocked down by a car, but he did not notice its close passing, or the blast of the horn. 'Probably Bordeaux suits him better than Paris,' said Moratin, 'for with his deafness he is in real danger in the middle of all this hurly-burly.'

We reached the Cours de Tourny which has been renamed after the politician Clemenceau. The hotel where Goya stayed for almost a year has gone. Near the Grand Theatre he paused for a moment beside a funfair carousel that had been abandoned on a patch of grass. He stared at the brightly painted horses, their square teeth and their frightened eyes. He put his hand on the shining flank of a painted mule that was carrying two big baskets, such as the women in the Pyrenees used to ride in, long ago. 'I have always preferred the mule to the horse,' he said. I noticed that he moved with awkward swaying steps as if he was on the deck of a ship and trying to compensate for the rolling of the waves. When Brugada accompanied him on such a walk he steadied himself by leaning on the young man's arm, but as soon as they reached a secluded back-street where there was no one to watch and maybe to laugh, he struggled to manage unaided and almost toppled over from the effort. 'After eighty years I am being carried around like a child!' he said. Later on that same day,

Brugada made too much of a show of the signs with which they communicated and Goya was suddenly furious. 'Can't you make your signs more discreetly . . . Do you enjoy showing everyone that old Goya can neither walk nor hear?'

The rain had stopped by the time we reached the church of St Seurin, approaching it through a tree-lined park that had been known as the Alley of Love because there were more prostitutes here as well. But now there were no signs of life apart from an ancient basset hound who was taking himself for a solitary walk. His coat was moth-eaten, his balls were very naked and he looked unfairly burdened by the weight of his huge jowelled head that he could hardly keep lifted above the ground. 'Another old man like me,' said Goya.

We looped back round, passed the Judaic swimming pool, the high walls of the cemetery, the complicated Last Judgement above the entrance porch of the cathedral where Goya's funeral was held and eventually we reached the wide square which holds the church of St Michael with the sharp-tipped Tower of St Michael standing next to it.

We sat in a little café on the edge of the square and drank mint tea from glasses decorated in twirling golden patterns. A picture of the Black Stone of Mecca hung on the wall. A woman's voice was singing guttural lamentations on the radio. At the next wobbly table a man with a voluptuous creased face grinned at us, revealing a row of golden teeth. Goya returned the grin.

There was a street market laid out on the paving stones around the church and its tower. A man wearing a woollen cap and several damp-looking jumpers over his long white robes was selling an aluminium saucepan and a record player that had lost its lid. A man in a fez was standing

guard over a pile of knitwear that was tangled irredeemably together as if it had been washed up in a storm. A woman with a high turbaned headdress, barefoot in the puddles, walked by with a baby tied to her back by a long patterned cloth. Everybody was very slow and quiet and preoccupied. Goya liked this place, felt at home, made drawings with the greasy crayon that he always used.

He could not be persuaded to enter the dark containment of the church, but together we walked around the tower to see if there was still a way of getting into its subterranean vault. In the old days the custodian of the tower and his family used to do their cooking at the mouth of the vault and were always ready to show visitors inside. By the light of a lantern you were led down a spiral staircase until you reached a floor that was soft and spongy underfoot. The air smelt sweet and sickly. When your eyes had adjusted to the flickering light, you saw that the walls on all sides were lined with the mummified bodies of human beings. There were about forty of them standing upright, including a general in full military regalia who had been killed in a duel, an entire family poisoned by mushrooms and a porter who had died while attempting to lift a heavy weight. The bodies were mummified naturally in the vault's cold, dry atmosphere. Some had been here for several hundred years, others, like the mushroom eaters, were quite recent additions. The ones that had fallen to pieces had been piled up in a crumbly heap in the middle of the floor. In the 1840s the writer Théophile Gautier described this vision of mortality as something 'more monstrous than Goya's *Caprichos*', but for Goya the scene held no fascination; the living interested him, not the dead.

In the spring of 1825 he was in very good humour. In

January he had managed to obtain a further six-month permit to stay France, claiming that 'the doctors say that if I could take the waters and frequent the baths at Bagnères, they are hopeful my health will be restored'. But he had no intention of taking the waters at Bagnères or anywhere else and according to Moratin his health could not have been better. 'He enjoys the city, the countryside, the climate, the food, the independence and the tranquillity. Since he came here he has had none of the [medical] troubles which bothered him over there . . .'

But when spring was moving towards summer he became seriously ill. The weather that year was very hot and apparently everyone thought that he was going to die, but he pulled back and recovered. He was then able to use the illness to its full advantage because once again his permit was about to run out. The two doctors who had attended him prepared a written declaration that he was suffering from 'hardened bowels, paralysis of the bladder and a large tumour on the perineum'. They concluded that the illness, compounded by the loss of the senses of hearing and sight, 'is incurable and it is at present absolutely impossible for the patient to do any exercise whatsoever'. This statement was translated into Spanish and countersigned by the Commissioner of Police and the Deputy Mayor. It was sent to Javier in Madrid who duly presented it to the authorities on his father's behalf. As a result a full year's extension was granted.

However, already by mid-June Goya had completely shaken off the effects of his illness and was back at work, 'very full of himself and rather arrogant, painting like nobody's business without ever correcting what he has done'. It was true that a cardiac disturbance made his hand

tremble and he needed to use a magnifying glass as well
as the spectacles to see the details of his own work, but as
he said in the letter to Ferrer, he had nothing but will
power, which he had in abundance.

In the autumn of 1825 he and his family left the hotel
and moved into a house on the Street of the White Cross,
not far from the church of St Seurin where the old basset
hound was out for a walk. In Goya's time this area was on
the edge of the countryside with a view stretching to the
north over meadows and vineyards and kitchen gardens.

The house has gone, but there are many others just like
it: a row of sandstone buildings, only one storey high and
as neat as family mausoleums in a cemetery. The neigh-
bourhood is as poor now as it was then and the street is
wide enough to be choked by lorries and streams of cars.
Goya's house had its own little bit of a garden and upstairs
the light came in from the north and the south. The road
was used every morning by the milkmaids who passed on
their donkeys, bringing milk and cheese to the markets.

It was here that Goya began to do lithography, working
in a fury of energy during the months of October,
November and December. He got materials and whatever
technical help he needed from a man called Cyprien
Gaulon who had been a primary school teacher and then
a soldier in Spain but had recently started a lithographic
studio.

Close to the north-facing window, Goya placed a lime-
stone slab vertically on a strong wooden easel, as if it was
an ordinary canvas. He covered the stone with a uniform
grey tone and worked with scrapers to bring in the first
miracle of light. Then he used the greasy crayon to
strengthen the shadows and give energy to the figures he

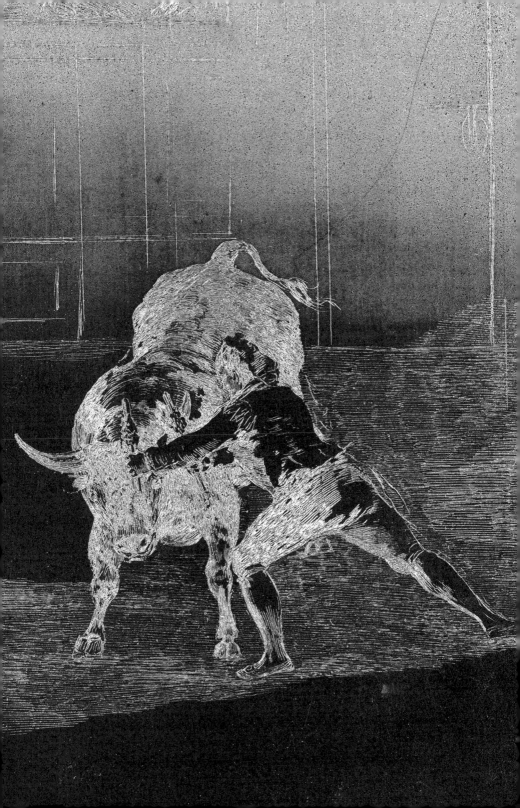

was making. He remained standing, walking backwards and forwards every other minute to judge the close and the distant effect of what he was doing.

It was here in the Street of the White Cross that he made the wonderful series of lithographs known as 'The Bulls of Bordeaux'. I like to think that when he looked out of the window he could gaze so far into the distance across the wide expanse of countryside that he could see the province of Aragon and himself as a child and as a young man there. He could see the bulls in the bullring, the people watching them and the people fighting them. He could see it and could hold the moment like a note of music, catching the muttering energy of a crowd, the glint of sunlight on a sword, the sliding smile on a face, and above all else, the solemn confrontation between the one who is about to kill and the one who is about to be killed.

In early December he wrote a letter to Ferrer and enclosed 'an attempt in lithography which represents a village bullfight', saying 'if you find it worthy of being circulated, I will send you as many prints as may suit you'. Two weeks later, when Ferrer had not shown much enthusiasm, Goya suggested 'giving them to a dealer in prints for a modest price, without mentioning my name'.

The prints were not sold and life went on and then, in May, with his leave again running out, Goya became restless and decided that he wanted to go to Madrid. As Moratin said, 'the journey will be booked three or four days in advance as usual . . . He is going alone and is dissatisfied with the French . . . If he has good fortune and arrives safely then you can welcome him; if not then don't be surprised, the least setback could leave him dead in the corner of some inn.'

He left on 10 May and arrived safely eight days later. He stayed with Javier and his wife and son Mariano, in the house on the Street of the Green Valley. On 30 May he wrote a letter to King Ferdinand, asking if he might be given a retirement pension, in view of his years of service. On 22 June 1826 his request was granted, with the acknowledgement that 'his advanced age promises that for natural reasons, the period in which he may enjoy these privileges will be short'.

I wonder if Goya became a different person when he was in the company of his son and his son's family. I wonder if the tone of his voice changed as he entered the house that he had given to them and looked at the furniture that had been his, the books which he had acquired over the years, his most loved paintings hanging from the walls and staring at him with reproach because he had deserted them, or, worse than that, with complete indifference because they no longer remembered him. And did he notice that some of the paintings had already gone, while others had been taken down and put to one side in a corner, waiting for the opportunity of being exchanged for a sum of money?

I suppose he might have walked into the house with a sense of proprietorial authority; after all he had paid for everything here and he was still paying. But somehow I think it is more likely that in crossing this threshold he was turned into an intruder, an uninvited guest, an old man who should have been dead long ago. I see him suddenly becoming fragile and querulous as he leans on the arm of his daughter-in-law, complaining about the ache in his leg, the weakness of his eyesight, the problems he has when he passes water, the alarming irregularity of his heartbeat.

Leocadia's body, Rosario's laughter, the smiling whores on the Alley of Love, the circuses, the fairs, the theatres and the restless curiosity of each new day in a foreign land, it all becomes as insubstantial as a dream. Instead, there is the solid and tangible apparition of this, his legal family: the three of them standing in front of him and watching him with something close to hunger. 'They want me to die,' he thinks and with that he feels the presence of Thin Death at his side, the face covered by a sackcloth hood and the eyes behind the slits in the cloth glinting like the eyes of a snake.

'I have a present for you,' he says to Javier, and he gives him some drawings he has made in Paris and Bordeaux. Javier flicks through them like a banker counting notes. Later he will stick them on to pieces of pink backing paper and change their numbers and move them into different sequences. He wants to have the most saleable ones together.

Goya takes his son's hands in his own, holds him in a tight grip and pulls him close, blood of his blood, the one surviving child from a long marriage. He feels the exhalation of this other man's breath on his cheek as he examines the face for what it shows and what it is trying to conceal. He sees a middle-aged man who looks older than his forty-six years, the features slack and heavy with an accumulation of disappointment and resentment. Javier does not want to be interrogated like this; he disentangles himself from the hands and from the eyes.

Money can be so complicated, especially within a family. It rustles and turns and whispers in the dark. It makes promises it cannot keep. It gets into people's bones and will not leave them alone for a moment. Javier had never

needed to work in all his life. He did nothing except count
his father's money, write letters to his father's bankers and
creditors, and deal with the sale of his father's possessions,
especially the paintings and the drawings. In the portrait
that Goya made of him on the eve of his wedding in 1805,
he appears like a young aristocrat, jaunty and carefree,
excused of all responsibility because he has youth and
beauty. But in the little drawing made almost twenty years
later, he has changed completely. He has the same heavy
profile as his mother, the same closed, inward stare.

In 1811, when the war had just ended and the famine was
about to begin, Goya and his wife had made their joint will
which had such a lasting effect on Javier's destiny. It is pos-
sible that Josefa had known she was going to die soon and
knew also that her husband had started or was about to start
an affair with Leocadia. That would explain why the terms
of the will were so drastic and so uncompromising.

With Josefa's death, Goya relinquished most of what he
owned. It was like a reversal of roles, in which he was the
young man who was free to escape from the confines of
his home as long as he took nothing with him, while Javier
stayed behind surrounded by all the material securities that
would protect him through the years that lay ahead. Goya
began his life with the beautiful Leocadia, who was five
years younger than his own son. He moved from the city
to the countryside, from Spain to France, from one rented
accommodation to the next, and the outpouring of work
never ceased except when he was ill and on the edge of
death. Meanwhile Javier stayed where he was, with his
wife and his child who was no longer a child, and he did
not even manage a visit to Bordeaux until his father was
dead and buried.

I wonder if the ghost of Josefa sometimes came to Goya in his dreams, shouting angrily into his deaf ears that he had only married her because her family helped with his career, that he had never loved her or shown tenderness to her and then as a final insult he had betrayed her irrevocably by setting up house with that woman. Did she make him remember how much she had suffered with each new pregnancy: the miscarriages, the stillbirths, the funerals? And now there was only Javier left, the one inheritor of the family name who must be protected at all costs.

So Goya dedicated himself obediently to the support of his son and his grandson, securing investments on their behalf and making sure that they would always be safely provided for. Perhaps it was for their sake, more than his own, that he struggled with such dogged determination to keep his income as Court Painter, even though he despised the King and the Court whose favours he begged with such obsequious devotion. Once he was in Bordeaux, he hardly touched this monthly salary, but passed it on to his bankers who invested it for him. At first he relied on the financial assistance of Javier's father-in-law Martin Goicoechea. When he died in 1825, Goya's affairs were handled by a family friend and then by the French banker and entrepreneur Jacques Galos who was amassing a considerable fortune from a number of private enterprises, including the sale of arms to South America.

Goya had an annual income of twelve and a half thousand francs, which was about four times more than his friend Moratin managed on. By living simply and in the poorest districts of the city and by selling the work he was producing in Bordeaux, he was able to save a great deal. Javier's letters to his father are full of detailed questions

about what was happening to the money and Goya answered him, point by point, with an almost childlike openness. 'I was at Monsieur Galos's on Saturday and I received the two months' pay cheques you sent me, I still have the other inscription of nine hundred and seventy-nine francs and if you send the [other] two pay cheques I think I should be able to invest up to twelve thousand reales a year, which is, is it not, a perpetual estate for Mariano and his descendants.'

In one of these letters to Javier he mentioned that when he died he wanted to be buried in the brown robe of his patron saint, Francis of Paolo. This hermit saint, who was said to be able to read people's minds, who comforted King Louis XI of France when he was ill and terrified of dying, was famous for his austerity and his humility. He owned nothing and he needed nothing and the religious order he founded was called the Minims, the least brethren. Somehow Goya was able to feel that he was poor even though he was rich. The wealthy man existed only for the benefit of Javier and Mariano, while the poor man lived a simple life in Bordeaux, with Leocadia and Rosario. So when he died he was wrapped in those brown robes, even though the sum of sixty thousand francs was rustling and whispering in his French bank accounts – enough to acquire one of those exquisite country mansions that look as delectable as an iced cake and bear such names as My Desire or My Pleasure.

It's very complicated, this business of trying to disentangle Goya from his money, but I will end with two contrasting images. During his short stay in Madrid in the summer of 1826, he agreed, at the request of the King, to have his portrait painted by the celebrated and very

academic Court Painter, Vicente Lopez. Here Goya sits with heavy self-assurance in a chair, holding his brushes in one hand and his palette in the other. He wears a grey silky suit and a white frilled shirt. His left eyelid droops slightly, perhaps as the result of a mild stroke. His expression is stubborn and defiant, but he is unmistakably a member of the establishment, a respected public figure.

But also while he was in Madrid he must have used his old etching press to produce a series of etchings. One of these – the old man on a swing – seems to be a self-portrait, especially if you compare it with the portrait made by Rosario at around this time. The old man wears a rumpled suit and a white shirt. His feet are bare and his calves are knotted with muscles. His face is filled with a look of wild and private joy. In the next moment he will have swung himself out of the containment of the picture and into the black eternity that lies beyond.

And then what? Goya was back in Bordeaux in July and by the end of the year he had moved again; this time from the Street of the White Cross to the Street of St Seurin, which was in the same district, but closer to the church. The houses were small, solid, two-storey buildings and several of them were used as brothels, which was why the street was more commonly known as the Alley of Love. The land had previously been the site of a large cemetery and when people dug their gardens they often came across human bones. Goya had a well in his garden which he shared with some of his neighbours. Monsieur Dubédat, the pharmacist who owned the house, lived next door.

From the back window he could see the heavy, crouching form of the church, as firmly rooted in the ground as an old tree. From the front window he could watch the whores. I am sure he liked the contrast. I am sure he enjoyed walking through the tree-lined street where women sold their bodies and men bought them, until he had reached the church which was full of the bodies of the dead. A beggar would be holding out his empty bowl in the arched shadows of the entrance and when Goya passed

into the building he could feel the quietness enclosing him like a forest.

A subterranean crypt lay in the deep heart of the church. The warden unlocks a metal gate and you go down stone steps that have been weathered into smooth hollows by the feet of all those who have been here before. You enter the crypt, a pocket of cold space smelling of age and incense. The air is so still it is as if time with all its hungers has never been allowed to intrude. The floor is littered with decorated marble tombs, like the chrysalides of huge insects, waiting for the moment when they can break out of their shells, spread their wings, fly away.

Goya saw a monk on his hands and knees in prayer turned into a strange four-legged animal by the folds of his garment. The scattering of thin blue stars painted on the walls were like tiny bubbles of thought. In places the walls were stained black by the smoke from candles and flaming lanterns. He could just distinguish the carved figure of a naked woman whose arms were crossed over her breast. She looked much older than the church that held her.

He climbed the stairs and returned to the world outside, the sunlight flickering on the nervous leaves of the elms, glinting on the hair of the women. It was like a practice for dying, this transition from light into darkness, from darkness into light.

It was probably while he was staying in the Alley of Love that Goya made the painting known as *The Milkmaid of Bordeaux*. Some people have suggested that it might be a portrait of Rosario, but it seems unlikely since she was only thirteen, while this woman must be several years older. Her smile holds a delicate balance between sadness and joy. Maybe he watched her going by every morning on her

donkey and asked her to pose for him, or he might have
caught her face in his mind's eye and turned to it later
when he was alone and working. There is no way of find-
ing out more; all that has survived from this time are a few
fragments of information: there were young elm trees
planted along the Alley of Love; Leocadia once referred
to the painting as *The Milkmaid*; she kept it in her posses-
sion for as long as she could, after Goya died.

Another year was coming full circle and in July 1827
Goya was once more making the journey to Madrid to
collect his money: his old bones rattling in the carriage, his
eyes straining to see whether that was a procession of
people or a line of scraggly bushes in the distance, a forti-
fied town or the peak of a mountain. Once again he left
the flat monotony of marshlands and pinewoods and
crossed the steep barrier of the Pyrenees. Here the land
belonged to the Basques who had been glad to kill the
English as well as the French during the war. Their houses
were like prisons, with the heavy shield of each family
sculpted over the doors. Goya could watch the crackling
energy of their speech without making any attempt to read
the foreign language that was on their lips. He remem-
bered the Andalusian joke: a Basque writes the name of
Solomon and pronounces it Nebuchadnezzer. He thought
of Leocadia, who would shout at him in Basque when she
was particularly exasperated by his age, his stubbornness
and the deafness that enclosed him.

He must have stayed with his son on the Street of the
Green Valley and while he was there he painted the portrait
of his grandson Mariano who had just turned nineteen.
There is the defiance of youth and the triumph of youth-
ful beauty in the face of this young man, and also perhaps

an element of disdain. Later he will buy himself the title
of the Marquis of Espinar from a broken-down nobleman
who has no more use for it, and he will sell all the paint-
ings he has inherited and he will lose all the money that
has been so carefully accumulated on his behalf.

While Goya was in Madrid I would have him visiting
the House of the Deaf Man. Officially it belonged to
Mariano, but it was being kept under the watchful eye of
Javier who had all sorts of plans for improving it and making
it into a grand country residence. Once his father had died
the paintings on the staircase walls were obliterated when
a new branching pine staircase was constructed, and the
colour of the walls was made to match the pink marble
bust of the artist which stood on the landing. But for now
the house was empty and unused and Goya was free to go
there.

When my mother was approaching her own death she
said she wanted to visit the house where she had lived for
the last twenty years. She slowly made her way from room
to room. She sat in the chairs she had always sat in. She
gazed out of the windows at the garden she had tended
through the seasons. She talked to the cats who had been
her sole companions for such a long time. She hardly
seemed to notice the paintings. Later she said, 'I felt like
a ghost. I kept asking myself who the place belonged to
and where had they gone. I had no sense of it being my
house, none at all, although the cats seemed to recognise
me.'

So Goya entered the house that he had once inhabited.
He stood in one of the big rooms and waited until he had
grown accustomed to the dim light. According to the inven-
tory which was drawn up later, a child's armchair was placed

between the painting of the Sabbath and the painting of the cudgel fight. He sat down in it now and tried to remember what it had been like to live here and the person who he had been then.

I would like to think that it was while he was in the House of the Deaf Man that he wrote a letter to Leocadia. It is the only letter from him to her that has survived, the only chance of hearing how he spoke to her, how he viewed her. The letter bears no date, but it is presumed that it was written in Madrid in the summer of 1827.

'My dearest friend,' he wrote, his spelling and punctuation as erratic as ever and his hand shaking from the effort of holding the pen.

> My dearest friend,
> I have just read your most beautiful letter right through and it has made me so happy that even if I tell you it has made me completely better I am not exaggerating at all. A million thanks . . . I am most grateful for all you tell me about the carriage and much more about the friendship which my Rosario has established with Madame, the companion at the draughts board, to whom through you I send my respects and a thousand thanks on my knees. I repeat that you should address the envelope to this house because that way I shall have more time for writing without going out . . . A thousand kisses and a thousand things from your most affectionate Goya.

By September he was ready to trundle back to Bordeaux with his royal pension in his pocket. It was raining hard when he arrived and it went on raining; the streets of the

city were like shallow rivers. Moratin had been waiting to say goodbye to him. He was about to go to Paris to help set up a Spanish school there. He was not well and would die only a few weeks after Leocadia wrote to tell him of Goya's death. Once he had left Bordeaux there were no more of his gossipy letters to friends, describing how Goya spent his time.

Around the beginning of 1828, the pharmacist who owned Goya's house and the house next door in the Alley of Love decided that he wanted to have both buildings demolished and something much larger erected in their place. So, once more, the little family was on the move.

They were offered the use of several rooms in an apartment being rented by a good friend called Pio de Molina. The house was number 39, Fosses de l'Intendance, now called the Cours de l'Intendance, a fine street in the centre of the city, facing the Cathedral of Nôtre Dame and close to the Grand Theatre which Goya had never bothered to visit because the performances were too serious and not to his taste.

On the ground floor there was a jewellery and goldsmith's shop on one side and a bookshop on the other. The woman who owned the bookshop lived here with her two children and so did the woman who ran the lottery shop next door. The owner of the house was a widowed carpenter who lived on the first floor with his two sons. On the second floor, which had the tallest and most decorated ceilings and the biggest marble fireplaces, there was a Mexican heiress, her husband and her young baby. The details of her inheritance were just being arranged in the first months of 1828, turning her into one of the wealthiest individuals in the whole city. Molina and the Goyas seemed to have

shared the next floor and nobody has worked out who was living in the attic.

A stone staircase with a decorated iron banister led the way from one floor to the next in an elegant sweeping curve. I see the old man making the long climb with slow steps, gripping tightly to the cold metal, and pausing to catch his breath on each landing. Once he had reached his own apartment, he could look out of the back window at an enclosed courtyard with just a glimpse of the sky, or out of the tall front windows which commanded a view of a busy street and the sharp spire of the cathedral. This was his home for the few months that were left to him.

None of Goya's many houses has survived, except for the one where he was born in that village with its wide and empty landscape and the one where he died, in a room on the third floor of a late eighteenth-century building, right in the crowded heart of a city.

When I went to see number 39, Fosses (now Cours) de l'Intendance, it was in the process of being turned into the Spanish Cultural Institute of Bordeaux, but, even though everything was in a state of upheaval, the Director of the Institute said he would show me around.

The front door is sandwiched between a smart dress shop and a shop selling candles and frilly household goods. A brass plaque fixed to the outside wall shows Goya in profile, glancing with a weary eye at all the activity going on around him.

Passing from the busy street into the narrow entrance hall I was swamped by a babble of sound from several radios playing different music, men in overalls shouting to each other, the whizz of drills, and the bump and crash of heavy things being moved about. The air smelt of fresh paint and plaster. The looped intestines of new electricity cables lay in heaps on the unfinished concrete floor, along

with ladders and trestles, sheets of plastic and open cardboard boxes.

I was shown the old wine cellar where a central heating system was being installed. The muffled space was bright with strip lighting and all the walls were smooth and white apart from one small patch which had been left untouched. Here, someone long ago had written the Spanish word for blood, *sangre*, in lamp black on the old plaster. No way of knowing who wrote it or why, just the fact of this strangely disembodied fragment floating across the barrier that separates time past from time present. I wonder if they decided to preserve the word, or to cover it over.

Back in the entrance hall I looked up at the staircase rising almost miraculously through the three floors of the building. And there was old man Goya, gripping with his left hand tight on the banister rail as he pulled himself from one shallow stone step to the next, grunting from the effort. Someone said he once stumbled and fell on these stairs, but they are not steep and he was not badly hurt.

I followed him as far as the second floor landing where I stopped to peer into the grand suite of rooms which had been rented by the Mexican heiress. I could not enter because the floors had just been varnished, but I could see five narrow French windows leading on to a balcony, and the marble fireplace where the heads of two Grecian caryatids were peering tentatively out of the swathes of plastic sheeting in which they had been wrapped.

On the next floor, where Goya and his family had lived with Pio de Molina, a group of men in overalls were sitting around a trestle table and eating lunch. The front rooms were less grand than those downstairs and there were no Grecian maidens decorating the fireplace, but a few curling

acanthus leaves instead. The walls were a pale green and
the smell of cooked meats and cigarette smoke mixed with
the smell of emulsion paint.

There was such a sense of emptiness and absence here
that I did not know what to do to bring it back to life, so
I placed the thought of an easel right in the centre of one
of the rooms and around the walls I leant a few small
unframed canvases, the little still lifes that Brugada said
Goya produced in the time it took him to smoke two ciga-
rettes. They have all since disappeared without trace, but
I could imagine a group of soft-skinned peaches, the almost
human body of a pear, a dried codfish, along with several
other fleeting images of reality that he caught and held.
In 1831 a painting Goya had made of a dog was offered as
a prize in a local raffle and in 1832 a family living in the
Alley of Love bought one of his pictures from a second-
hand dealer at the Saint Fort fair. This one showed a dog
motionless with fright in front of a snake. The family kept
it hanging above their fireplace, but no one has seen it
since.

Now in a corner of that empty, pale green room, I place
the image of a bed. It is a single bed, of the style known
as French Empire, made out of polished walnut wood, with
a solid curved back and deep sides so that it looks like a
little boat. There is a drawing made shortly after Goya's
death which shows him lying on a bed just like this and
that is why I can picture it now. I would never have recog-
nised him from the drawing; he looks nothing like my idea
of him.

The bed does not seem to belong here in the front room
so I trundle it over the polished wooden floors and into
one of the small rooms at the back, with a window out on

to the enclosed courtyard. The problem is that no one knows which of the rooms he was using or where he was when he died. I abandon the bed.

Now I bring in the piano that Goya rented for Rosario so that she could take lessons. Leocadia said it was Rosario's chief recreation and she was very sad when it was taken away. There is a velvet stool in front of the piano and Rosario is sitting on it, her feet not quite able to reach the pedals and her small hands struggling to span the notes. The delicacy of her features and her naturally pale skin make her look troubled already, even before the troubles have come. The future is gathering around her like storm clouds.

But now she plays and old man Goya stands beside her and smiles and watches the music she is making. The piano lid is open and he leans forward to place the palm of his hand on the vibrating strings, hoping to catch the melody that is passing through them. But he catches nothing. 'Nothing,' he says, 'nothing,' and Brugada who is also in the room remembers this scene and describes it later.

Pio de Molina walks in. He is a man in his early fifties. His face has the pallor of a southern skin, his hair is black and his features are big and strong. In 1823 he was the 'Constitutional' mayor of Madrid, but now he is simply another foreign exile. He is wearing a black jacket over a white shirt and Goya is in the middle of painting his portrait, although the work will never be completed.

Goya at his easel, Molina sitting still, Rosario playing the piano, Brugada watching it all, Leocadia cooking a meal perhaps; a gathering of friends and family, poised on the edge of change. They are all very aware of the old man.

They can see how he grows weaker and more vulnerable day by day. There is no hope of recovery for him now and a little fall or a brief fever could topple him like a bullet in his heart.

They see the effort it takes for him to hold a paintbrush or a piece of chalk, the effort of lifting a spoonful of soup to his lips and the shame of spilling it. They see him trying to light a cigarette with wavering fingers clenched on the match. They note each tremor that passes through his body, the way his left eyelid droops, the trembling of the lower lip, the struggle that is needed for him to rise to his feet, take a few steps and sit down again. Sometimes when he is in a chair, his eyes closed and the skin of his face cold and luminous, it is as if he has gone already.

Leocadia, who was once infuriated by the erratic swings of his moods, is now pleased when he is impatient or irritable, because it pulls him back into the world. It is his distance and his indifference that frightens her, his absence when she is sitting close beside him. She does not want him to die; none of those who know him here want him to die. Even the big-boned Molina is as solicitous as a mother towards him.

In the afternoon Goya takes a siesta, lying on his single bed, his mind drifting out into the vastness of sleep. Leocadia comes and stares at him, shocked by how far away he is and how casually he is able to desert her like this, without even pausing to say goodbye. She is tempted to touch the parchment skin of his face and hands. She bends close to listen to the reassurance of his breathing, to watch the flutter of movement behind his eyelids.

During these last months, Goya very much wanted to see his son. It was as if he wanted the child from his first

family to come and see him here with his second family, to give him the blessing of acceptance, in spite of everything. He invited Javier repeatedly. He offered to pay all the expenses. He extolled the benefits of Bordeaux, especially the financial benefits. And finally, in January 1828, Javier said yes, he would come, probably in the summer. In the meantime he would persuade his wife Gumersinda and his son Mariano to visit the old man.

On 17 January, Goya wrote a letter to Javier: 'I am overjoyed with the news about . . . your travellers. So they are coming to spend a few years [sic] here and you too when you are able. I shall be happy and won't have to travel to see you.'

On 3 March, Javier wrote to say that the trip had been cancelled and on 12 March Goya wrote back, offering to pay all the expenses for them 'here and in Paris', and he added, 'and you must come too'. On 26 March the mother and son were indeed on their way and Goya wrote, 'I am impatient for my dear travellers to arrive . . . They should enjoy themselves here and if you come this summer it will be everything I could have wished for.'

He went on to tell Javier that he had been unwell but was feeling much better now and hoped soon to be as he was before. He said, 'I owe my improvement to Molina who has been telling me to take powdered valerian herbs and I am very pleased to now be in a good condition to receive my beloved travellers.'

Gumersinda and Mariano arrived on 28 March. Leocadia had made rooms ready for them in the apartment. Goya was quite overwhelmed by the excitement, and as he said in his next letter to Javier, 'So much happiness has affected me a bit and I am in bed. God knows how I would like to

go and see you, go and fetch you and then my happiness would be complete. Your Father, Francisco.'

On 1 April they all lunched together, but the food troubled him and he went to bed immediately after the meal. When he woke at five on the following morning he was unable to speak, and although his voice returned to him within a few hours, he remained paralysed down one side of his body. Not much time left now.

40

It took Goya thirteen days to let go of life. On the first day, once the power of speech had returned to him, he was clear and lucid. He realised that this was different from all the other occasions when he had wavered on the edge of mortality; this time he was not going to be able to pull himself back.

The members of his two families had always kept separate from each other, but now here they were gathered around him: his daughter-in-law and grandson on one side, his mistress and her child on the other. And because he knew he was really dying, he announced to them that he wanted to make a second will, a document to acknowledge his relationship with Leocadia and to make sure that she and Rosario were provided for financially after he had gone. His daughter-in-law was quick to reassure him. There was no need to worry, she explained, he had done it already. Everything was in order. He must have believed her and Leocadia certainly believed her as well.

He began to slip further away. When he spoke his words were often nothing more than a soft babble of drifting associations, almost impossible to understand. But he could

still recognise the people who came into the room, their solemn faces hovering above him like pale balloons.

The paralysis down one side of his body had left him as helpless as a fish out of water. When he tried to smile, a corner of his mouth lifted in a crooked grimace and one eye was unable to close so that it continued to stare with unblinking intensity, even when he slept. But his other eye could follow a person's movement, his hand could answer the pressure of another hand and his deaf man's voice, even more hollow and toneless than before, could still enunciate a name or the stumbling words of a short sentence.

Goya was performing a slow and quiet death and everyone who was close to him in one way or another was caught up in the process, a witness to the effort, the struggle and the seriousness of what he was doing. Leocadia sat beside him. She offered him a sip of water, a spoonful of thin soup. She wiped the sweat from his face with a damp cloth, she helped wash his limp body, she held his hand, she held his gaze. Rosario approached like a wild animal, trembling with fear and disbelief, holding back her tears until she had escaped from the room. Molina, whose portrait would now never be finished, and Brugada, who would have no portrait at all, hardly ever left the apartment. The woman from downstairs who ran the bookshop, the carpenter from the first floor who owned the building, and the Mexican heiress came to say goodbye. Braulio Poc from the chocolate house came as well and I imagine him with a bushy moustache and smelling of strong tobacco, even though I have never seen a picture of him, only a reproduction of his twirling and confident signature.

Goya watched faces as he had always done; reading who

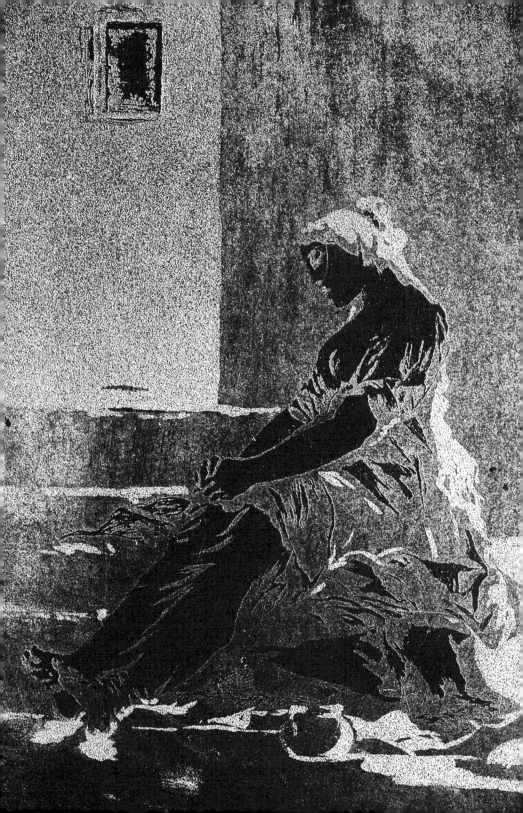

they were, what they wished for, what they were afraid of. He looked at Gumersinda and for a moment he confused her with his dead wife Josefa; there was something similar in their closed and resentful stare. He looked at Mariano, who had become such a fine young gentleman, a real aristocrat in his manner and way of dressing. But then a wave of anxiety passed through him like a fever because Javier was nowhere to be seen. 'Where is my son? Has he not been told that his father is waiting for him? Someone must fetch him at once! Ask Moratin to go . . . But where is Moratin? Why is he not here either?'

And suddenly from within this imagined scene of confusion I find myself again sitting at my mother's bedside and she is also drifting on the edge of death. Just like Goya she has suffered a partial paralysis which has given her a lopsided smile, an unblinking eye and a voice that is held in a flat monotone, rather like the voice of the deaf. Her face has the monumental solemnity of a mask. She is concentrating all her energy on what is happening to her, her own irrevocable departure.

She stares at me as if from a huge distance. There is a gentleness about her which I have not known before. Perhaps it was always there, but hidden under layers of rage and sorrow and only now has it been laid bare. I moisten her mouth with water on a little sponge. I dip my finger into a pot of honey so that she can suck the sweetness.

'How is Goya?' she asks in that blank, deep voice and I tell her again that he is fine, I am enjoying his company.

'Goya,' she says, trying out the sound of the word. And then, 'How old when he died?'

'Eighty-two,' I reply.

'Same as me,' she says and a lopsided wisp of a smile passes over the carved stone of her face.

'I went to the Prado,' she announces and in that moment she has fallen back into a restless sleep.

A few days after Goya's death, Leocadia wrote a letter to Moratin in Paris, telling him the stages of how it had happened. She described getting the apartment ready for the arrival of his grandson and daughter-in-law, the lunch, the illness, the paralysis, the desire to make a new will, the slow decline.

She said that on the night of 15 April she was in the room where he lay, but standing at a distance because by then he was breathing so heavily she could not bear to bring herself close to the bed. Molina and Brugada were beside him and a doctor was also present, but she made no mention of Gumersinda and Mariano.

Around midnight, Goya's body went through some sort of crisis, but by half past twelve he was calm and peaceful, as if he was sleeping. He died at two in the morning. The doctor said his resilience had been astonishing. He also said that he had not suffered at the end, but she doubted his reassurance.

I imagine Leocadia sitting silently in that room, waiting for the first light of the dawn to reveal the face of the old man she had lived with and loved. He had not asked for a priest to come and give him the Last Sacraments and forgive him his sins. He had died with the same stubborn independence he had used for living. I wonder though if his expression had softened, now that he had lost the need to hold on.

Leocadia helped to wash him and dress him in fresh white nightclothes with a cap on his head to keep him

warm. His arms lay stiffly at his sides, on the clean, tightly folded sheets. People came to pay their last respects. The lithographer Gaulon arranged for a young painter called Francisco de la Torre to make a drawing of the deceased that would be turned into a limited edition of prints.

Molina and a friend went to the Town Hall to register the death. They got Goya's age wrong, stating that he was eighty-five years old and this mistake was repeated on the memorial stone.

The businessman Don Santiago Galos, whose portrait Goya had painted in 1826, went to the undertakers to arrange the details of the funeral and the burial. Goya was going to share the family tomb of Javier's father-in-law Martin Goicoechea, who had died three years previously. It just needed to be opened up to be ready to receive a new guest and Galos paid the total cost of one hundred and fifty francs himself.

On that same day the Spanish Consul came to the apartment on the third floor to certify that he had seen the corpse of the painter. With Molina and another man as witnesses, the Consul asked Mariano and Gumersinda what the deceased's estate consisted of. They replied, 'He left nothing', and this was duly written down and signed. That evening Goya was placed in his coffin, wrapped in the brown robes of a hermit monk.

The funeral took place at ten o'clock on the morning of 17 April in the church of Nôtre Dame. Brugada, Molina and Braulio Poc were among the pallbearers and Mariano and Gumersinda were the family mourners. I don't know what role was given to Leocadia and Rosario or to the young Guillermo who suddenly reappeared at his mother's side during Goya's final days. It was said that all the Spanish

exiles, all the artists and many of the people of the town followed Charles IV's Court Painter to his final resting place. I would like to think that an acrobat, a dwarf, a few prostitutes and a destitute soldier who had lost his legs in the Peninsular War were also there among the crowd.

The hearse made its way to the high-walled Chartreuse Cemetery where tombs and vaults and ornate family mausoleums stand in ordered lines along their named streets, like rows of neat little houses in a city for the dead. In those days it was still customary to pay for professional weepers to attend the burial ceremony. These were children between the ages of twelve and fifteen, dressed in strange coats made out of three layers of black capes, their legs bound in black stockings and their heads almost hidden under large felt hats decorated with crêpe ribbons – a good subject for a drawing done in greasy crayon and chalk.

And now I can't help seeing Leocadia standing in the spring sunshine beside the newly dug earth of the grave. She also is dressed all in black, with a black veil misting her face, and she looks just as she looked in the portrait that Goya made of her on a wall in the House of the Deaf Man, six years before. But the desolation on her face has increased with the passing of time.

41

I was not in the room when my mother died, but I was
with her shortly afterwards. I had never seen a dead person
before, never known the echoing solemnity of such an
encounter. She looked very distant and private now that
there were no uncertainties flickering like shadows across
the surface of her face, no restless dreams to wake her, no
questions needing to be asked or answered. She had
become a stranger I had never seen before even though
her features were as startlingly familiar as my own reflec-
tion glimpsed in a mirror.

Over the days and weeks that followed, I was busy with
the task of settling her affairs. There were letters to write
and documents to sign. There was an empty house brim-
ming with possessions that had suddenly lost their purpose:
chairs wanting to be sat in; curtains waiting to be drawn;
cupboards and boxes ready to be opened and closed again.
The paintings hanging on the walls, standing in racks in
the studio and rolled in tight bundles in the dark, were all
calling for attention like hungry animals demanding to be
fed. As I walked from one room to the next I became
increasingly aware of how little I knew of the person who
had lived here.

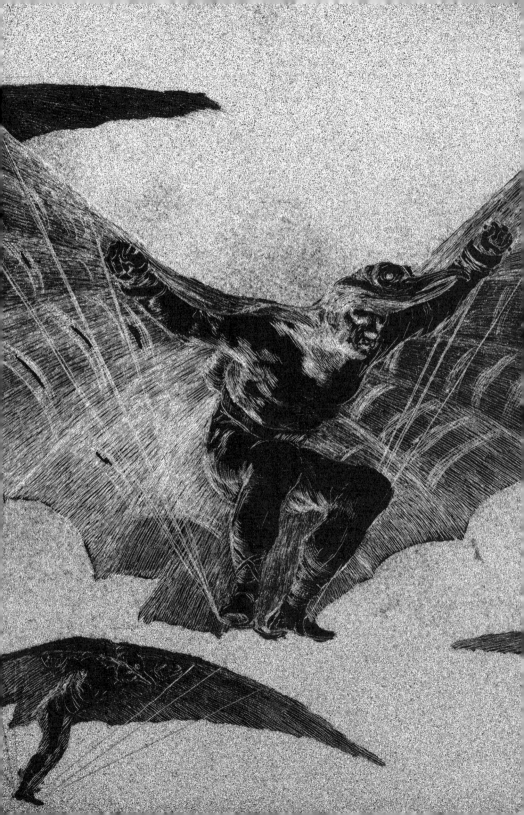

* * *

Once Goya had been stilled and silenced and placed in a coffin next to Javier's father-in-law the banker, he also became a stranger to me. In the telling of his story I had tried to keep up with the stages of his life, sometimes bobbing alongside him for a little while, sometimes staring at his hunched figure striding ahead of me. I had grown accustomed to the fierceness of his jutting lower lip, the droop of his eyelid, his habit of muttering loudly to himself and not caring who was listening and I was caught up in the spinning energy of the man as he hurtled relentlessly through the years.

He was always busy with his work. He never stopped or even slowed down except on the occasions when he was knocked off his feet by illness and then he would emerge from his bed still weak and shaking to return to work with even more ferocious intensity. I even wonder if he noticed the people who were close to him, who offered him food or money or admiration, an arm to lean on or a bed to sleep in, or was he too preoccupied to acknowledge their existence? It sometimes seems to me as if all the love and compassion, the indignation and fascination, the horror and the fear that he felt towards his fellow human beings was sucked directly into the pictures he made, leaving nothing over for those who shared their lives with his.

As I looked at Goya lying dead, I suddenly felt angry with him. I wanted to shake his cold body and shout into his deaf ears. I wanted to hammer on the side of his coffin, demanding an explanation from him. Why had he not bothered to sort things out before the end came? Was it because he didn't care about anyone?

None of this matters, of course; it is the work that is the thing; it is the work that transcends all the petty confusions of a life. It's just that after Goya had gone I felt so sorry for Leocadia. I don't know how close she was to him, and I don't know what he promised her in the way of love or eternity. It might be that she had simply imagined hearing him say on his deathbed that he wanted to write a new will that made provision for her and her daughter. And then she must have also imagined that Gumersinda told him not to worry, everything was in order.

Anyway, when he died there was no evidence of a second will. I suppose it is possible that Gumersinda had it in her possession, but crumpled it up and burnt it because she was cruel and greedy and then she told Javier what she had done and he was glad because he was cruel and greedy too and he had always resented Leocadia and was afraid that she was planning to steal his inheritance. But then why did Goya not arrange things with his lawyers and bankers, since all his other affairs were so well managed and his hoard of money was proliferating comfortably in trusts and bonds and private accounts? Did he choose to ignore the fact that old men must die eventually? Was he ashamed of taking responsibility for his mistress and his illegitimate child? Or did he not want to bother himself with thoughts about what would happen to those around him, once he had gone?

After the first shock of grief and the first flurry of practical necessities that surround a death, Leocadia must have asked Gumersinda if she knew where the will could be found. She must have explained that she had no money of her own, that the rent for the apartment was only paid until the end of the month and even the piano that Rosario

loved to play was only rented and would have to be returned soon. And Gumersinda must have said not to worry, her husband Javier was in charge of such things, he would be here any day now, such a pity he had not been able to arrive in time to say goodbye to the father he loved so much.

Leocadia wrote two letters to Moratin in which she confided the predicament she was in. She said she had to keep going for the sake of Rosario who was in a state of despair. She said that Molina was 'concerning himself' with her situation and he had already gone to Madrid to talk to the son and to find out if there was anything in the will. She said that in the meantime she was looking for a cheaper apartment.

Javier would have received the news that his father was dying by 10 April at the latest. If he had set out immediately he could have reached Bordeaux in time to accompany the funeral cortege to the cemetery. But there were a lot of practical things he wanted to do before he made the journey.

On 15 April he obtained a copy of his own birth record and on the 16th he took this, along with the will written by his parents in 1811, to have it certified by the Royal Notary. On the 17th the French Consul General added his signature to the documents and Javier was ready to leave.

In Bayonne he crossed paths with Molina and so he learnt that Goya was already dead and buried. He arrived in Bordeaux on the 23rd and went straight to the lithographer Gaulon who introduced him to a solicitor and a sworn translator. He was told that the will did not conform to French requirements and even though it declared him to be 'our unique and universal heir' he would need to

have everything validated again in Madrid, in the presence
of four credited witnesses.

Before pursuing the next stage of the legal proceedings,
Javier went to confront Leocadia. She described their meet-
ing to Moratin:

> He came to see me three times and after having taken
> the silver dinner service and the pistols he asked me
> what accounts his father kept and told me, 'Since you
> are in a foreign country, this is in case it suits you to
> return to your own; here you have an order for a thou-
> sand francs and you can keep the clothes and furni-
> ture.'

Moratin was in Paris and could do little to help her; he
was seriously ill by now and would be dead within a few
weeks. Molina had gone; he must have realised that there
was nothing to be achieved in Madrid. Galos and Brugada
were both keen to help Javier. Leocadia had no one to turn
to. In her second letter to Moratin she explained her state
of mind and something of her attitude towards Goya.

> Our sadness increases – no small thing given the uncer-
> tainty in which we live. And in spite of his genius, our
> pain will be eternal, no matter what Destiny has in
> store for us.

Javier had just enough time to arrange for his father's
memorial stone to be prepared, but not enough time to
notice that Goya had been given the wrong age. He then
returned to Madrid to begin the third round of solicitors and
notaries. On 10 May his four reliable witnesses, including

an uncle and a brother-in-law, testified that he had 'the legal right to the entire estate of the late Francisco de Goya y Lucientes and the late Josefina or Josefa Bayeu, his parents'. Back in Bordeaux on 24 May, he deposited the necessary documents with the Royal Notary and the monies began to be released. Goya had left an estate which was valued at some four hundred thousand francs.

Leocadia found herself a cheap place to rent in a run-down street near Braulio Poc's chocolate house, the same street where so many of the destitute soldiers from the Peninsular War were living. Pierre Lacour, who had previously given Rosario drawing lessons, was the only person who tried to help her and her daughter. He had them provided with food and took on responsibility for the young girl's education, at least for a while.

Leocadia had kept twenty of Goya's drawings, including the series known as *The Madmen of Bordeaux*, but she must have sold them or given them away before she left France. In 1869 they appeared at an auction, bound in red silk covers, and fetched the sum of one franc ninety-five centimes.

She gave Lacour her copy of the *Caprichos* with an explanation of the etchings translated into French and written out in her hand, but it has since disappeared without trace. For a while she kept the painting known as *The Milkmaid of Bordeaux*, but already in 1829 she was thinking of selling it, as she explained in a letter to a friend of Goya's who had previously expressed interest:

You insisted a great deal that I should give you *The Milkmaid* and that I should tell you what I wanted for it. I said I did not plan to sell it and that if some day

I were to sell it because I was in need, I would prefer
to sell it to you. We are in that situation now. The
deceased told me I should not accept less than an
ounce [of gold].

In 1831 Leocadia made an appeal for charity to the
French government: 'She now finds herself and her daugh-
ter reduced to a state of poverty and seeks the aid which
in its generosity the government accords to women of her
class'. She was going to receive one franc fifty centimes a
day, but then the award was cancelled.

She returned to Madrid in 1833, after the political
amnesty which allowed many of the exiles to go home. By
some strange coincidence of destiny, she went to live on
the Street of Disenchantment and that was where she died
in 1856.

Javier and Mariano busied themselves with the money
they had inherited and bit by bit it was eaten up, mostly
in railway speculations and property deals. Goya's work
was sold piecemeal and Murray's 1834 *Handbook for
Travellers in Spain* mentions that 'those who admire him
should visit his son Don Javier (9, Street of the Waters)
who has many of his father's sketches and paintings', imply-
ing that acquisitions were easy to arrange. Javier died in
1854 and when Mariano died twenty years later, he was
not in possession of any examples of his grandfather's work.

For a long time Goya was left undisturbed in the
Chartreuse Cemetery in Bordeaux. The grave was over-
grown and the iron railings that surrounded it were broken.
In 1869 there was talk of bringing the artist home to Spain,
but this came to nothing and it was not until October 1888
that the plans for an exhumation finally went ahead.

A witness described watching how the stone was
unsealed and removed. The gravedigger entered the vault.
The wooden coffins belonging to Goya and Javier's father-
in-law had disintegrated completely, but the remains of
two skeletons could be seen scattered on the earth. One
belonged to a small man and the other to a giant with a
strong, arched backbone, enormous shinbones and no head.

Now in my thoughts I find myself standing in that curi-
ously suburban cemetery, the little houses for the dead
stretched out in careful avenues. The air is cold and the
sky is grey and empty, but there is no rain. I am leaning
against a broken metal railing and looking down at the two
skeletons that have just been uncovered. I recognise Goya
at once because his short and stocky figure is so very famili-
ar to me, but someone standing close beside me says that
he is obviously the giant without a head; everyone knows
what a big frame he had and you can see how the spine
was curved from years of being hunched over his work.
And then he points to fragments of the brown cape of Saint
Francis of Paola clinging to the old bones and I know that
he is right and this is my man.

I wonder about the absence of the head. The two French
doctors who were probably with him at the end were both
anatomists and had done research on what could be learnt
from the structure of the human brain and the shape of
the skull. They must have taken Goya's head away with
them on the night after he died in order to find out what
secrets it held about the nature of greatness. And then he
was buried so quickly that there was no time to return the
head to him. Not that I think he would have minded.

After the exhumation the bones were placed in a box
and taken to the mortuary to await further instructions. A

year and a day later, when nothing had happened, they were returned to their original grave. There they stayed for a further ten years when they were again exhumed and taken to Madrid. For a while they lay in the cemetery of San Isidoro with a view out across the river and towards the hill where the House of the Deaf Man had once stood, and then they were transferred to their final resting place under the marble floor in the church of San Antonio de la Florida. If Goya had opened his eyes to look up, he would have seen the domed ceiling he painted in 1798. The figure of the saint has just brought a dead man to life, but the crowd of people who have gathered here are so busy with each other that only a few of them have noticed the miraculous transformation that is taking place. You can almost hear the noisy babble of their talk and laughter.

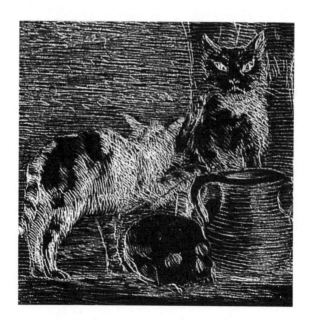

List of illustrations

The author and publisher are grateful to Calcografía Nacional, Madrid, for kind permission to reproduce these photographs of the copperplates.

Select Bibliography

My primary source of biographical information has been Pierre Gassier, Juliet Wilson and François Lachenal, *Goya: Life and Work* (Paris, 1971; Cologne, 1994). With regard to the final years in Bordeaux and especially Goya's relationship with Leocadia and the events surrounding his death, I am indebted to the fascinating and detailed picture given in Jacques Fauqué and Ramon Villanueva Etcheverria, *Goya y Burdeos* (Trilingual edition, Zaragoza, 1982). Jan Read's *Account of the Peninsular War* (London, 1978), was especially useful and provided references to the narratives of individual soldiers. Robert Southey's two volumes of *Letters Written During a Journey in Spain and a Short Residency in Portugal* (London, 1808) and Théophile Gauthier's *A Romantic in Spain* (English translation, New York, 1926) were the most vivid sources for the description of the countryside and way of life. It is from Gauthier that I took the idea of shaved mules looking like enormous mice and the woman in an inn breastfeeding a puppy. The deaf poet David Wright, who was also a family friend, wrote a moving account of his condition, *Deafness* (London, 1969).

Almost all of the letters quoted here are taken from *Francisco de Goya Diplomatario* (ed. Angel Canellas Lopez,

Zaragoza, 1981), the translations of which are my own. The exceptions are the legal documents relating to Goya's time of exile in France, which come from *Goya y Burdeos*, and the one letter from Goya to Leocadia which appears, in translation only, in *The Burlington Magazine* (Eric Young, 'An unpublished letter from Goya's old age', 1972, pp. 558–9).

Other sources include:

Juan G. Atienza, *Fiesta Populares e Insulatas* (Barcelona, 1997)

Major-General Lord Blaney, *Narrative of a Forced Journey Through Spain and France as a Prisoner of War in the Years 1810 to 1814* (London, 1814)

Edward Costello, ed. Anthony Brett-James, *The Peninsular and Waterloo Campaigns* (London, 1967)

Pierre Gassier, *Francisco Goya: The Complete Albums* (New York, 1973)

Nigel Glendinning, *Goya and his Critics* (Yale University Press, 1977)

—— *Goya's Country House in Madrid: The Quinta del Sordo* (*Apollo*, vol. 123, 1986, pp. 102–9)

Jacqueline and Maurice Guillaud, *Goya: The Phantasmal Visions* (Guillaud Editions, 1987)

Tomas Harris, *Goya: Engravings and Lithographs* (Oxford, 1963)

Martin Hume, *Modern Spain, 1788–1898* (London, 1900)

José Lopez-Rey, *Goya and his Pupil Maria del Rosario Weiss* (Gazette des Beaux-Arts, 1959)

Laurent Matheron, *Goya* (Bordeaux, 1857)

Priscilla Muller, *Goya's Black Paintings* (New York, 1984)

Musée des Beaux-Arts de Bordeaux, *Goya Hommages: Les*

Années Bordelaises 1824–1828 (catalogue, 1998)

National Gallery, William B. Jordan and Peter Cherry, *Spanish Still Life: From Velasquez to Goya* (National Gallery Publications, 1995)

Charles Poore, *Goya* (Scribners, 1938)

Royal Academy, *Goya, Truth and Fantasy* (catalogue, 1994)

Oliver Sacks, *Seeing Voices* (London, 1991)

A.L.F. Schaumann, *On the Road with Wellington: The Diary of A War Commissary in the Peninsular Campaign* (London, 1924)

Robert Sencourt, *Spain's Uncertain Crown* (London, 1932)

Victory I. Stoichita and Anna Maria Coderch, *Goya: The Last Carnival* (Reaktion Books, 1999)

Sarah Symmons, *Goya* (London, 1998)

Janis Tomlinson, *Francisco Goya y Lucientes 1746–1828* (London, 1994)

Antonina Vallentin, *This I Saw: The Life and Times of Goya* (London, 1951)

Susann Waldermann, *Goya and the Duchess of Alba* (London, 1998)

Rev. George Downing Wittington, *Travels Through Spain and Portugal* (London, 1808)

Acknowledgements

Bernard Cornwell recommended a list of fascinating and obscure books on the Peninsular War. Nigel Glendinning gave me some invaluable suggestions about where to begin with my researches and Sarah Symmons kindly read through the completed manuscript and offered helpful advice and insights. José Juan Chans Pousada, the Vice Director at the Estación Biológica de Doñana in Andalusia, and Audry Ozola, the Director of the Instituto Cervantes, Casa de Goya in Bordeaux, were both welcoming and informative. Much thanks is also due to my agent, Toby Eady, and to my two editors, Dan Franklin in London and Dan Frank in New York. In 1999, the Society of Authors kindly gave me a Travelling Scholarship which I used on my travels.

About the Author

Julia Blackburn is the author of *The Emperor's Last Island, Daisy Bates in the Desert, The Book of Color,* and *The Leper's Companions.* She lives in England.